THE
Archive Photographs
SERIES

SALISBURY PLAIN
A SECOND SELECTION

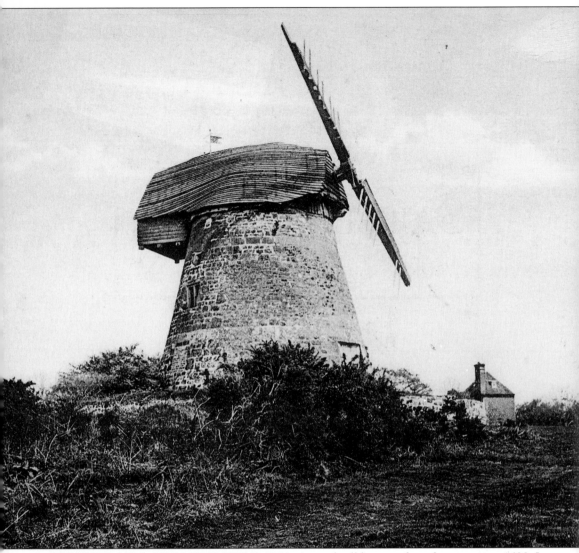

THE WINDMILL AT EAST KNOYLE, 1911. A windmill has stood on this site since 1632. In 1839 it was owned and occupied by Henry Seymour. William Perry was there between 1848 and 1859 at least. By 1900, however, only one pair of common sails remained and the mill had a gable-shaped boarded cap with a tailbox containing the winding gear. By the time of this picture the mill had ceased to operate following a fire. Many village celebrations took place in this area, including the 'Knoyle Feast' which was originally associated with the patronal festival of St Mary's Church. On the right one can see the engine house for the reservoir and water system of Clouds House.

THE
Archive Photographs
SERIES

SALISBURY PLAIN
A SECOND SELECTION

Compiled by
Peter Daniels and Rex Sawyer

CHALFORD

First published 1997
Copyright © Peter Daniels and Rex Sawyer, 1997

The Chalford Publishing Company
St Mary's Mill, Chalford,
Stroud, Gloucestershire, GL6 8NX

ISBN 0 7524 1028 8

Typesetting and origination by
The Chalford Publishing Company
Printed in Great Britain by
Bailey Print, Dursley, Gloucestershire

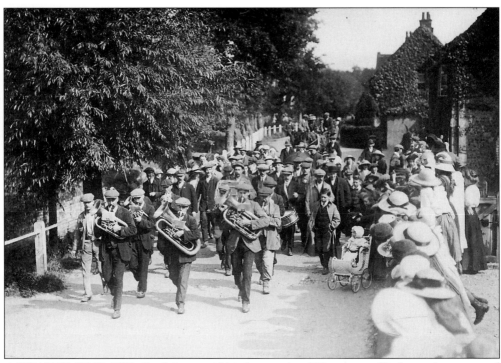

A HEARTY SEND OFF. On 5 August 1914 the people of Shrewton rallied round to say good luck and farewell to some local boys who had signed up to fight for King and Country. The lads were leaving to join Kitchener's army and the village band turned out to give them a memorable departure. On the right can be seen a number of spectators leaning over the fence of the school playground. The River Till runs along the left side of the picture.

Contents

Introduction 7

1. Amesbury 9

2. The Nadder Valley 25

3. The Wylye Valley 43

4. The Till Valley 57

5. The Avon Valley 75

6. The Bourne Valley 91

7. Aviation (The Early Days) 113

8. The Photographs of Austin Underwood 121

Acknowledgements 128

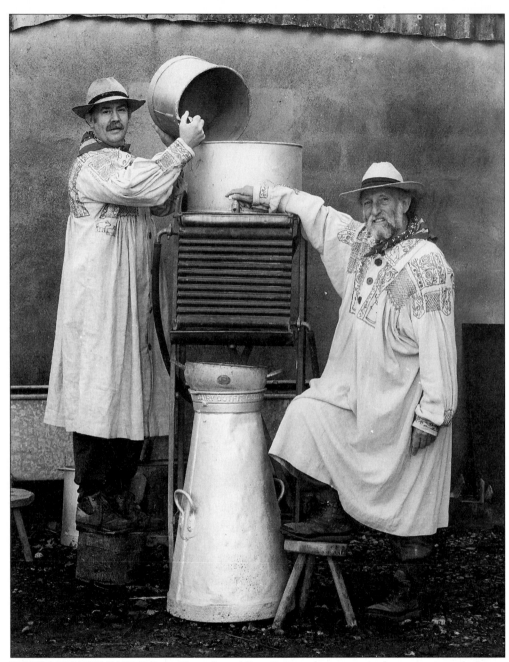

DOWN ON THE FARM. Peter Daniels and Rex Sawyer demonstrate the operation of a Lister Milk Cooler. This type of machine continued to be popular until well after the Second World War. Note the low inlet for water to enter on the right and the outlet at the top left. This kept the cooler full of moving water and the corrugations increased the surface area. The picture was taken at Farmer Giles Farmstead, Teffont Magna in the Nadder Valley in October 1997. The beautifully embroidered smocks and the milk cooler are part of a large collection of agricultural memorabilia collected over many years by John Vining. A visit to the farm is thoroughly recommended. (Photograph courtesy of David Perkins, Kallans Photography, Salisbury)

Introduction

It is always a privilege as well as a time of excitement to work on a book of this nature, to record something of the communities, the events and a way of life which has now all but gone. People seem eager to share with you their earliest memories or to display photographs and other memorabilia which link them with the family, friends and places they once knew. Sadly, the earlier inhabitants of the Plain, who wielded the scythe or the anvil, or kept the village tavern or post office-cum-store are dwindling fast. There is now a second or even third generation who keep these memories alive for us.

Tracking down the custodians of this earlier rural existence is part of the excitement. Living in quiet retirement themselves, often – though not always – some distance from the homes their families knew for generations, can mean lengthy detection. There is also the problem of security. Understandably, many people are suspicious of allowing strangers into their homes. For this reason I have always attempted to find a long-standing and respected citizen of each area with a personal knowledge of its inhabitants to act the role of intermediary. Maureen Atkinson, for example, secretary of the Bourne Valley Historical Records and Conservation Society, was a very helpful link in my Bourne Valley investigations. Her personal knowledge put me in touch with a host of older residents and enthusiastic members who so helpfully assisted my researches.

The boundaries of Salisbury Plain are vague. Ella Noyes, writing at the beginning of the twentieth century, defined its limits as Red Horn Hill above Urchfont to the south of Salisbury and Mere to Ludgershall travelling west to east. Within this area of gentle rolling downland the Plain is divided by a series of rivers flowing southwards towards Salisbury where they merge with the Avon and flow onwards to the sea at Christchurch.

Having focused our attention in the first volume on the military aspects of

the Plain, Peter Daniels and I have now turned to the village communities which lie along the river valleys of the Nadder, the Wylye, the Till, the Avon and the Bourne, which all flow through areas of fertile pastures and outstanding beauty. In making this decision, we have allowed ourselves a little geographical licence. For example, East Knoyle lies a trifle north west of the Nadder Valley and the section on the Till includes the area further north around Market Lavington and out as far as Rollestone camp. The murder of the Salisbury taxi driver Sydney Spicer in 1920 occurred a short distance east of the Bourne Valley.

The photographs in this book, many of which have never been published before, depict the lives of ordinary people in these valleys in the late nineteenth and twentieth centuries when their day-to-day existence rarely took them more than a few miles from their homes. We take a look at Amesbury, which has developed into today's flourishing town, and because the Plain played such an important role in the growth of aviation, one section looks at the lives – and often deaths – of the brave pioneer airmen whose efforts assisted the development of the new aerial technology. The book finishes with a further view of the Plain through the work of the late Austin Underwood, a local photographer and journalist who lived and worked lifelong in the area.

Peter Daniels' extensive library has provided the vast majority of the photographs you will see here. They include many examples of the work of Tom Fuller, Albert Marett and Charlie May, pioneer photographers of the Plain who have given us such wonderful glimpses into a world now long past.

One
Amesbury

THE EARLIEST KNOWN PHOTOGRAPH OF AMESBURY. This picture of Salisbury Street, almost certainly taken before 1880, shows the thatched Ivydene Guest House to the left of the large tree. Owned by the maltster and antiquarian Job Edwards, it burnt down in 1911. To the right of the tree lies the post office. To the right of the post office is the late nineteenth-century home and workshop of William Bishop, carpenter and general craftsman. The modern day roundabout is situated in front of this scene.

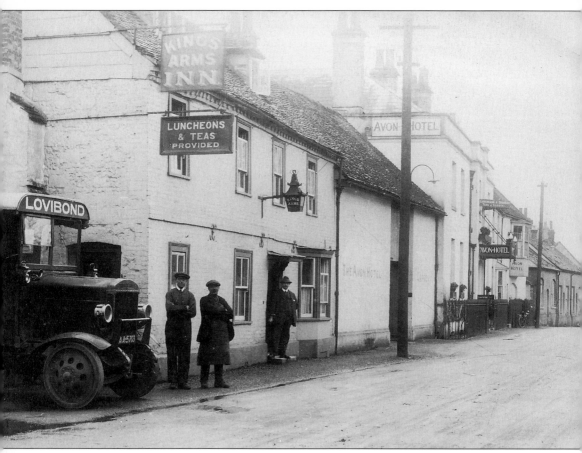

CHURCH STREET IN THE EARLY TWENTIETH CENTURY. The King's Arms Inn on the immediate left, once known as the Saracen's Head is believed to date from the eighteenth century. A Thornycroft lorry is delivering beer brewed by John Lovibond and Sons of St Ann Street, Salisbury. Next door is the Avon Hotel, previously a vicarage and now the Antrobus Arms.

Opposite: SALISBURY STREET, 1913. On the left is Birdcage Row, so named because of the little birdcage latticework porches. They were originally estate workers' cottages, shops and a school, but have since been converted into commercial properties. On the right are the Bell Inn and Soul Brothers' shop. John Soul was a baker, antiquarian and a well known local scout master who wrote several small books about the town. He was also a Druid. On the right, in the distance, lies the Queensberry Hotel, now a solicitor's office.

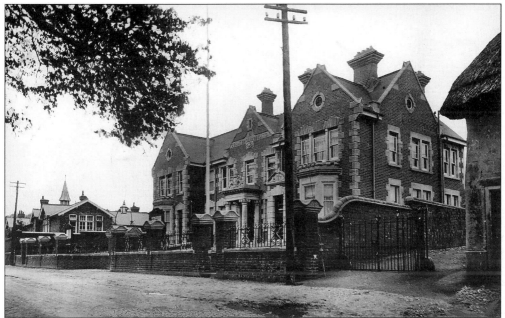

THE POLICE STATION AND SCHOOLS, 1913. The school was built in 1901 and amalgamated with many smaller charitable and private institutions governed by the parish church. The police station, built around the same time, was once the divisional headquarters for the area. Over the side door behind the telegraph pole is a carving of Stonehenge. This was later transferred to the new police station in Salisbury Road, where it can be seen inside the porch.

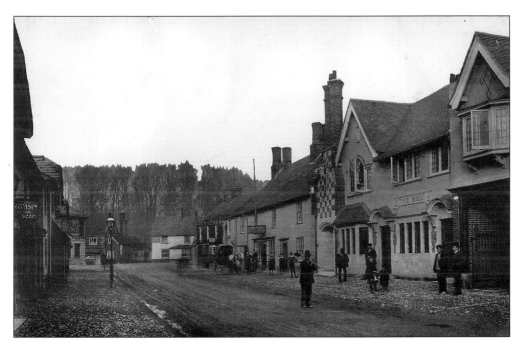

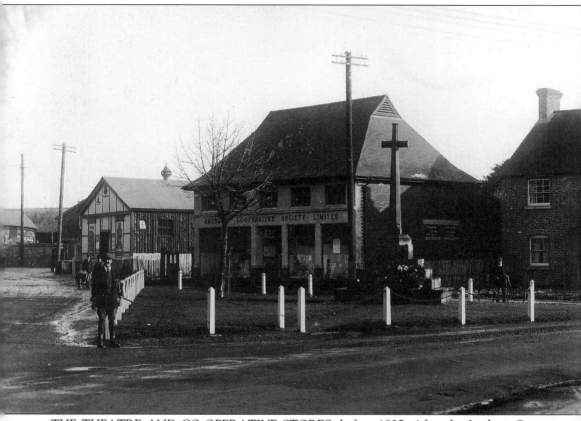

THE THEATRE AND CO-OPERATIVE STORES, before 1925. After the Ivydene Guest House was burnt down in 1911 this central site remained open ground, and a travelling bioscope regularly performed here. The wooden theatre seen on the left and the Co-operative Store were then built. The theatre later developed into a cinema managed by Leonard and Ivor Buckland. When its popularity led to overcrowding, it was moved temporarily to the bus station site whilst the modern Plaza Cinema was built. This, too, has now been demolished.

Opposite: AMESBURY HOUSE IN THE 1960s. Built in the early nineteenth century, this was the temporary home of the Antrobus family while the Abbey was being refurbished. Owned at one time by Colonel Bartlett of Milston it was later converted into six flats, one of which was the home of the Beacham family. Julian Beacham can be seen here on his new Vespa motorcycle (VHR 786). The house was demolished in the late sixties to make way for the new library and health centre.

COLDHARBOUR COTTAGES AWAITING DEMOLITION IN 1937. These humble cob-walled cottages were previously the homes of employees of the Antrobus estate. They were built in the middle of a broad droveway, sometimes 150 feet in width, along which vast flocks of sheep and cattle were herded. Some of the cottages were still standing during the Second World War but were later replaced by council houses in which the two people shown in the picture would have been accommodated.

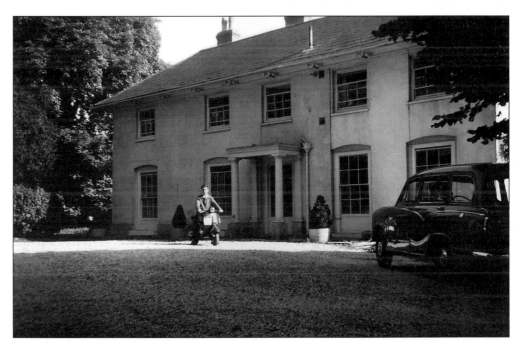

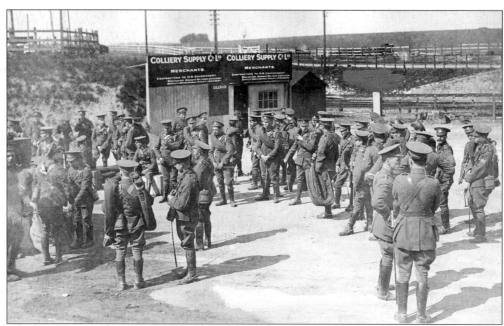

SOLDIERS AT AMESBURY STATION DURING THE GREAT WAR. After several unsuccessful attempts to create this railway line, it was finally opened in 1902 as part of the London and South Western Railway. During the First World War a further line was constructed to serve the rapidly growing army camps at Larkhill and beyond. Amesbury Station seemed to adapt itself well to both normal peacetime tranquillity and frantic military activity during the two wars. Here we see members of a cavalry unit enjoying a casual break whilst awaiting onward transportation.

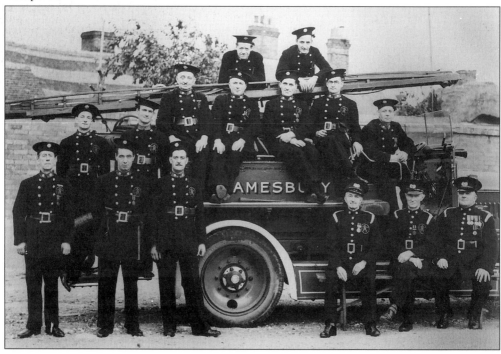

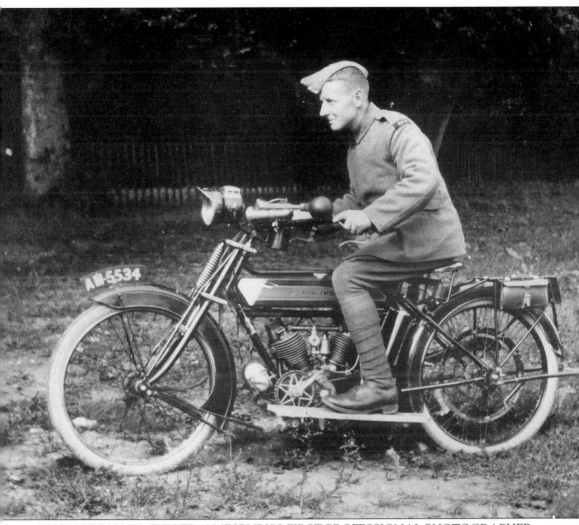

THOMAS LIONEL FULLER, AMESBURY'S FIRST PROFESSIONAL PHOTOGRAPHER.
Much has been written about Tom Fuller in the first volume of Salisbury Plain in The *Archive Photographs* series. Born in Tonbridge Wells in 1885, he came to Amesbury in 1911 after serving a five year apprenticeship in the photographic trade. Not only did he produce photographs for the civilian market but also for the military authorities. Later in the First World War he joined the Royal Flying Corps. In this picture he can be seen in uniform riding a 3hp Royal Enfield motorcycle (model 140). During a long career, which spanned more than fifty years, he collected a gallery of Salisbury Plain military photographs which remains unrivalled.

Opposite: AMESBURY FIRE BRIGADE, 1942. This photograph is believed to have been taken in the George Hotel car park, which was next to the fire station. Bill Todd and T. Vallance can be seen at the back, and pictured left to right in the middle row are Harry Maggs, B. Matthews, Richard Yapp (grocer), Tommy Creed, A. Williss, Arthur Chaldicot and T. Russ. In the front row are A. Zebedee (butcher), Peter Dimer, Les Yeates, T. Mathewes, Andrew Sloan (garage proprietor) and Captain C.A. Eyres. Their fire engine is a Braidwood type appliance manufactured by Dennis Brothers of Guildford, Surrey.

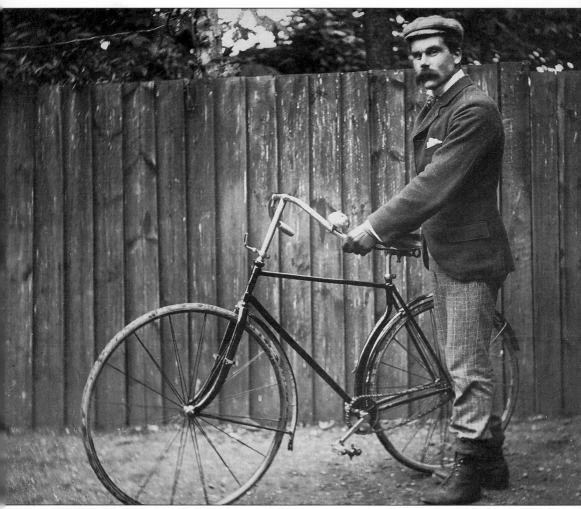

AN EARLY AMESBURY CYCLIST. Sydney Hinxman was a very respected town councillor of his time. He was employed as a gardener on the Antrobus estate. The picture above is believed to have been taken at the dawn of the twentieth century or possibly in the 1890s. We can see Sydney dressed for the occasion: his check breeches are tucked into his boots and he is wearing leather gloves. His jacket appears to be one size too small! The bicycle would seem to be very unusual, with the front wheel being larger than the one at the back. Although the tyres are made of solid rubber a well-sprung leather saddle was fitted to provide some degree of comfort.

Opposite: PREPARING FOR A BANQUET! This photograph, by Tom Fuller, would appear to record the festivities at the time of King George V's Coronation. The revellers are dressed in their Sunday best, and all but one or two of them wear a hat. They are about to sit down to tea perhaps. A variety of sandwiches and cakes have been laid out on the tables. The pottery is all of the same pattern and is likely to have been commissioned just for this special occasion. It was usual for events such as this to take place in the grounds of Antrobus House.

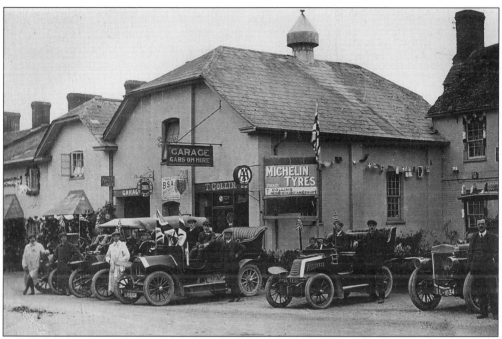

CORONATION DAY, 1911. This was the scene outside Tom Collins' garage and cycle shop at the northern end of Birdcage Row in Salisbury Street. The picture was taken during the celebrations of the Coronation of King George V. The building is believed to have been a school in earlier times, and during the 1940s and '50s Noyce's grocers was to be found here. It is now the Friar Tuck Café.

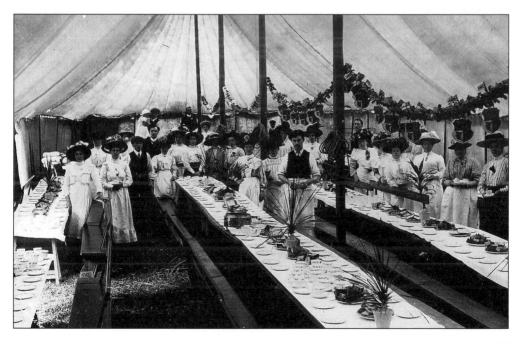

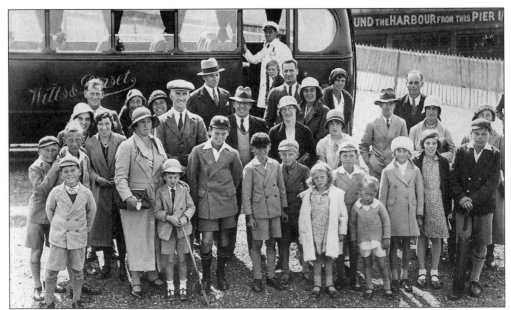

A VISIT TO THE SEASIDE IN 1933. This enjoyable excursion in a Wilts and Dorset saloon bus was to Portsmouth and Southsea. Terry Heffernan, who later worked at the Larkhill School of Artillery, is the young boy holding his spade and standing with his parents, Kathleen and Henry. Perhaps you can recognise one or two of the other day trippers?

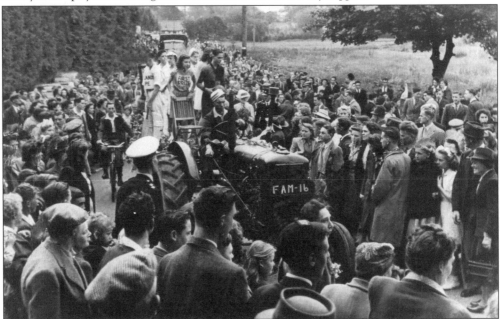

AMESBURY CARNIVAL, 1948. This event was a particularly enjoyable occasion as it was the first carnival to take place after the Second World War. The procession can be seen at the bottom of Church Street going into the recreation ground. In earlier days the carnival was held in the grounds of Amesbury Abbey. The young woman standing behind the chair on the back of this tractor has been awarded the First Prize. This 1947 Fordson tractor (FAM 16) and its trailer were provided by Harold James Street of Ratfyn Farm, Amesbury.

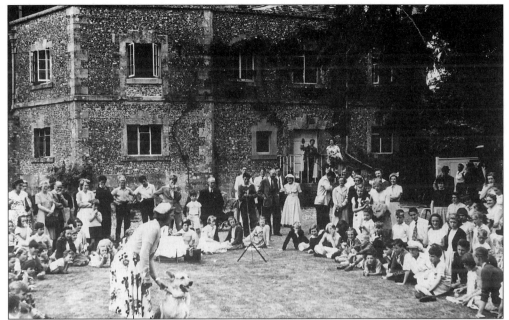

KENT HOUSE GARDENS IN THE 1950s. Kent House was the original gate house to the Amesbury Abbey estate and was extended gradually over a number of years. The gateway leading to Countess Road can be seen to the right. Church and school functions such as fêtes and garden parties were held in the gardens from time to time. Peter Binns, the church organist at that time, and Mrs Williams (the stand-in organist) are both present. A woman with an Alsatian dog appears to be entertaining the spectators.

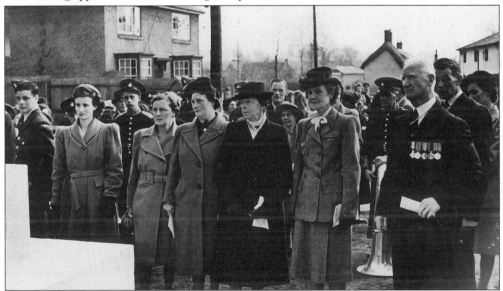

ADDING THE NAMES OF THE WAR DEAD IN 1947. At this time the War Memorial stood on the green in the centre of Amesbury. Members of the Amesbury Band can be seen including John Baker (centre left), a long standing member who worked at Boscombe Down. The man on the right with the medals was Harry Harbour, who kept the wireless shop in High Street. It was a solemn and moving event for those who attended.

QUEENSBERRY BRIDGE, AROUND 1907. Here we are looking eastwards towards the town. On the right in the distance can be seen the tower on the school built by the Reverend Meyrick. The entrance to Amesbury Abbey lies beyond the lodge house on the left. The bridge was built by the 3rd Duke of Queensberry in 1775, when the stagecoach era led to the construction of a new road and more prosperity for the town.

Opposite: THE APPROACH TO STONEHENGE DURING THE INTER-WAR YEARS. It would appear that the houses in the centre of the picture are being demolished. The roof tiles on the left hand dwelling have already been removed. On the right stands the Stonehenge Café which was run in the 1930s by Clement G. Billett, who lived at Watergate, Countess Road, Amesbury. An early AA box can also be seen. The man in the foreground is walking his dog, an unlikely event along this stretch of road today! An airfield was situated near here during the early 1900s. It occupied the position shown on the extreme left in the background of this photograph.

20

A TOLLHOUSE AND THATCHED COTTAGE IN STONEHENGE ROAD, 1905. Built by the Amesbury Turnpike Trust to take advantage of the burgeoning coaching trade in 1762, this tollhouse remained until the 1920s. By that time the coaching era had long given way to the railways. The cottage on the right was formerly Pink House School and once the home of a Miss Sandell. A second toll house was built in Countess Road.

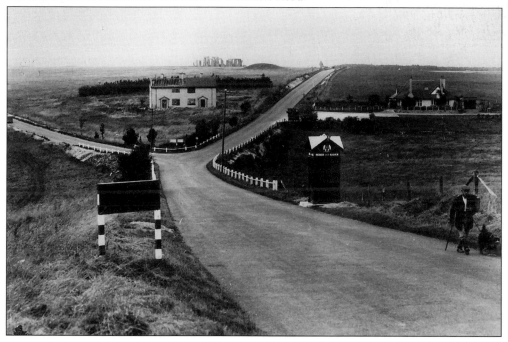

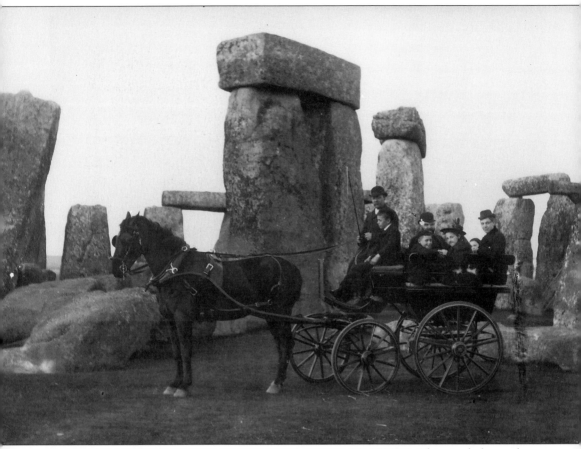

A FAMILY OUTING IN THE EARLY TWENTIETH CENTURY. This single horse-drawn wagonette at Stonehenge may well have been hired from a nearby hotel or livery stable, of which there were many in South Wiltshire at the time. Capable of carrying eight people in relative comfort, carriages like this were surprisingly fast and accidents were commonplace. The picture has been taken from a large glass photographic negative that was recently discovered in a Christchurch flea market. Unfortunately, the photographer did not make a note of the exact date of the picture and the names of the people are also unrecorded.

Opposte: AN EARLY MOTOR ACCIDENT NEAR STONEHENGE. On Tuesday 17 July 1913, Captain Clutton and a young man named Hawkins were driving up the slope towards Stonehenge when the steering on their car failed. It ran into a bank and turned a somersault. Both occupants were thrown out. Hawkins was seriously injured and taken to Salisbury Infirmary. Captain Clutton only suffered a broken wrist and was taken back to Amesbury. The car was a Coventry-registered Clement-Talbot. The photograph was taken by Tom Fuller, whose bicycle can be seen in the background!

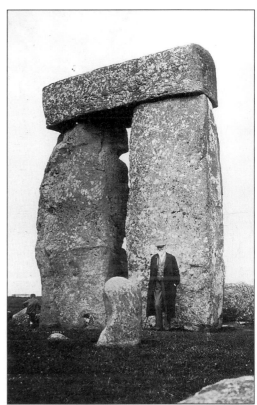

THE GREAT TRILITHON,
STONEHENGE, IN THE 1920s. Sir Oliver
Lodge is shown in the foreground. He was a
physicist who was instrumental in the
development of radio receivers. In 1919 he
retired to Lake in the Avon Valley after
resigning as principal of Birmingham
University. He died in 1940.

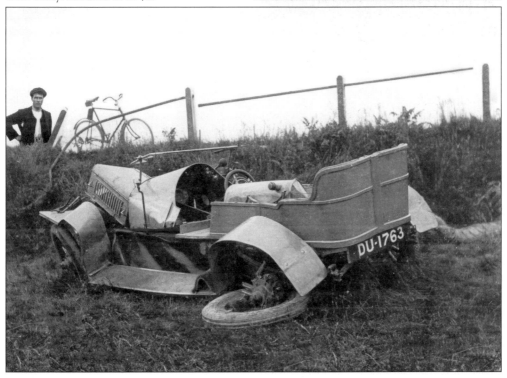

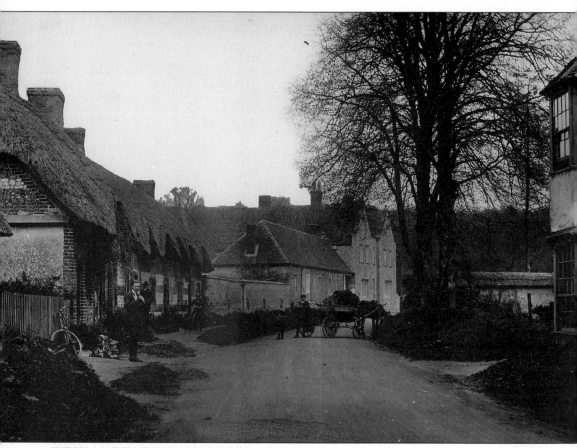

WEST AMESBURY IN NOVEMBER, 1915. West Amesbury House, which can be seen in the distance, belonged to the Antrobus family. Sir Phillip Antrobus, who died recently, lived there, as did several of his predecessors. The family still retains the manorial title of Lords of the Manor. This picture postcard was written by a young man who, interestingly for the time, knew shorthand. He was writing to his sister in Manchester to tell her that the previous evening he had walked the $3\frac{1}{2}$ miles to Stonehenge in the dark.

Two
Nadder Valley

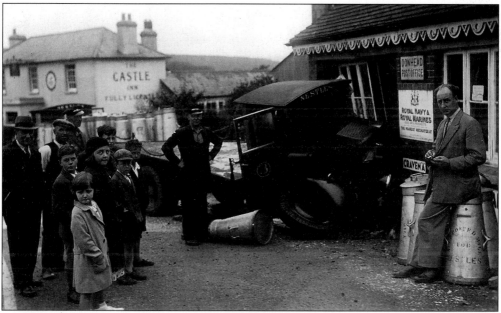

A NESTLÉ LORRY ACCIDENT AT DONHEAD. This incident occurred along the A30 at Brookwater, Donhead St Mary, near the Castle Inn, on 25 August 1938. The Donhead post office, which also had a telephone exchange, is shown on the right. The sub-postmaster, Mr Mayo, is believed to be the man on the extreme left. The lorry is not easily identified in its crashed state but would appear to be a Commer. The load of 17-gallon milk churns is being transferred to a second Nestlé lorry which is to be seen in the background.

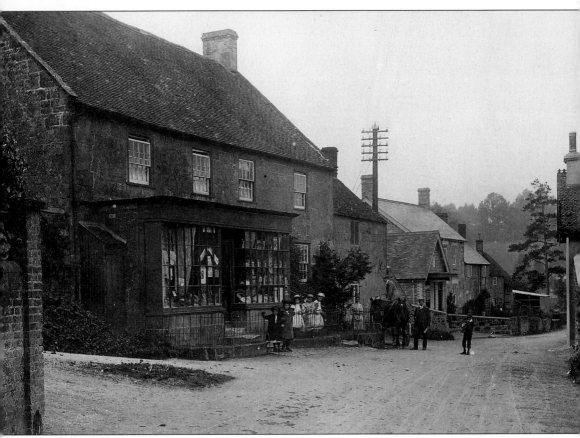

THE VILLAGE SHOP AT LUDWELL, BEFORE 1911. Scammells' grocery store is shown on the left with the bakehouse next to it. A two-wheeled cart appears to have been loaded ready to make deliveries. There are three young ladies standing in front of the shop. Further on, Bennett's butchers shop can be seen jutting out into the road. There are then three cottages. In one of these lived James Penny, who used to take watercress to Semley Station in a horse and cart for his employer Mr Lucas. With him lived his wife and seven children: William, Frank, Percy, Polly, Edith, Nancy and Virtue.

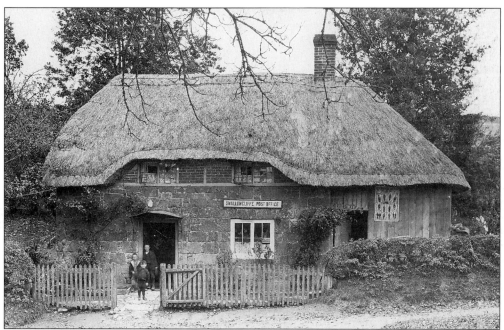

SWALLOWCLIFFE POST OFFICE, BEFORE THE FIRST WORLD WAR. Three children are standing at the door of this building, which can still be seen along the A30. Mary 'Polly' Burt (née Clarke) was the sub-postmistress here from the end of the nineteenth century until its closure in the thirties. It is now a private residence. The poster that is fixed to the wall on the right carries a promotional message for 'The British Army'.

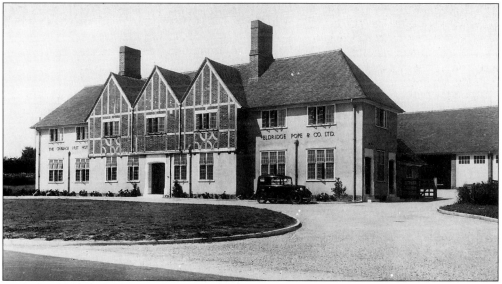

THE CRIBBAGE HUT HOTEL, SUTTON MANDEVILLE. The building replaced a much earlier inn of the same name which existed further west along the A30 towards Swallowcliffe. The old inn was demolished in 1935 when road widening proved necessary. The landlord, Albert Trulock Spenser, went on to the new hotel until his retirement. Today it is known as the Lancers. The tiny Austin car parked outside may well have been owned by the individual who took this picture.

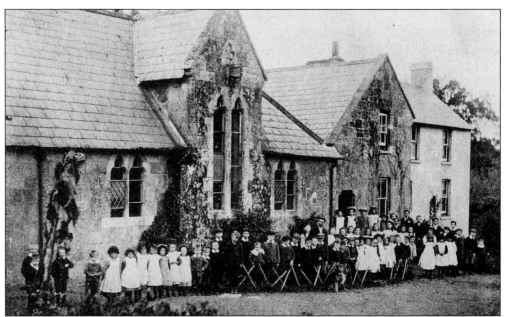

FOVANT SCHOOL IN EDWARDIAN TIMES. This mixed elementary school was built in 1847 for 100 children. The headmistress was Miss Edith Pratt. The children appear to be standing behind some sort of interlaced fencing to keep them in position and, unusually, there is a dog sitting proudly in front. The school had just closed at the time of writing and the children now attend Dinton First School, a picture of which can be seen on page 35.

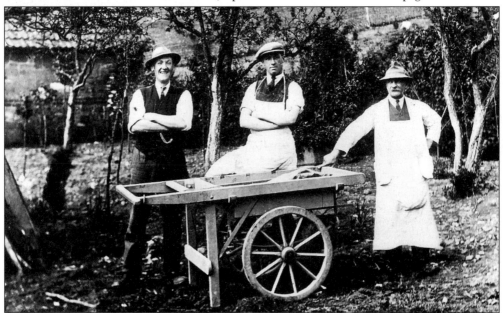

FRANK READ, THE FOVANT BUILDER. Mr Read lived at the Croft at around the time of the First World War but carried out his business from a galvanised shed at Mill Hill on the Dinton road. He is shown on the right. Pictured in the centre is Jack Coombes, who lived in the cottage now known as Oakhangers' Barn. Charlie Foyle, on the left, lived at Moor Hill. In front is a typical builder's hand cart of the period, a vehicle that was both practical and versatile.

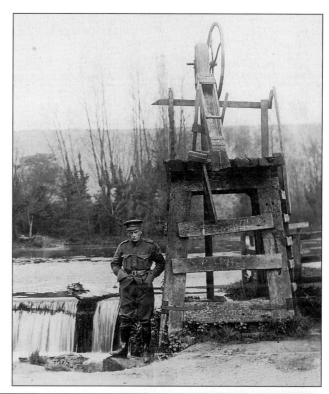

FOVANT LAKE AT THE TIME OF THE FIRST WORLD WAR. Previously known as 'Tumbling Bay' or 'The Soldiers' Delight', the lake rises from springs and then passes through the village to meet the Nadder further north. The pump was used to convey water to West Farm. A chute can be seen at the top, down which water was channelled to facilitate the filling of horse-drawn carts, bowsers and water butts.

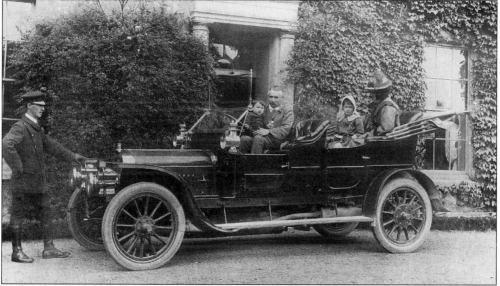

A SCOUT MOTOR CAR AT FOVANT RECTORY. The car was owned by the Reverend Maitland Arthur Shorland who was rector of Fovant from 1898 to 1919. He was obviously a man of means. Here he can be seen outside the rectory with his wife and daughter in their chauffeur-driven 18/22 hp touring car. This picture was taken in 1911, two years after the car was manufactured at the Scout Motor Works at Bemerton, near Salisbury. His eldest son, Midshipman John Maitland, died at the Battle of Jutland on 31 May 1916 while serving on HMS *Invincible*. He was only 17 years of age.

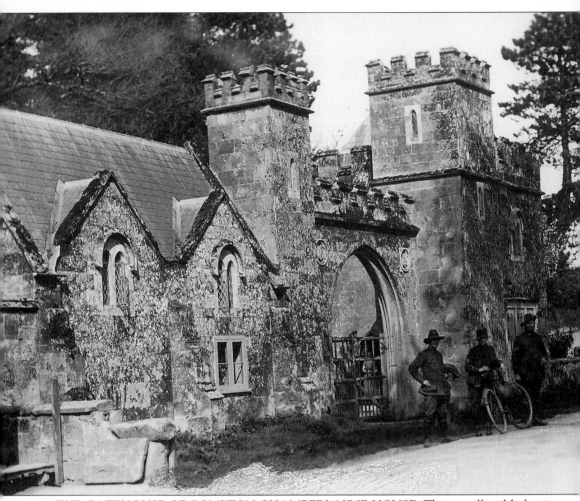

THE GATEHOUSE OF COMPTON CHAMBERLAYNE HOUSE. This castellated lodge is situated along the A30 just east of the village. The original picture postcard, which depicts three Australian soldiers, was posted in Hurdcott on 7 August 1918. The message reads: 'Dear Ma and Pa, This picture of a lodge and lodge gate to a mansion [is] just near our camp. The camp is on the left of the road a little further along. Your loving son, Will.' The lodge ceased to be a residence in the 1960s but has recently been restored.

Opposite: BURCOMBE FROM THE AIR. The Ship Inn is the white building shown in the foreground. In 1867 John Hibberd held the premises as both inn and shop but by the time this picture was taken it was just an inn. The landlord, Benjamin Gumbleton, a 6ft 4in ex-Coldstream Guardsman, presented this photograph to a customer on 7 June 1930. To the left can be seen the village mill with the River Nadder running west to east in the background.

JESS AND KATE AVERY OF
COMPTON CHAMBERLAYNE,
AROUND 1912. The Averys lived in
the gatehouse of Compton
Chamberlayne House, a photograph of
which has been reproduced on the
opposite page. From here Jess ran a
garage and a bus service into Salisbury.
His brother owned a shop at Barford St
Martin and another brother owned the
mobile home site in the same village.

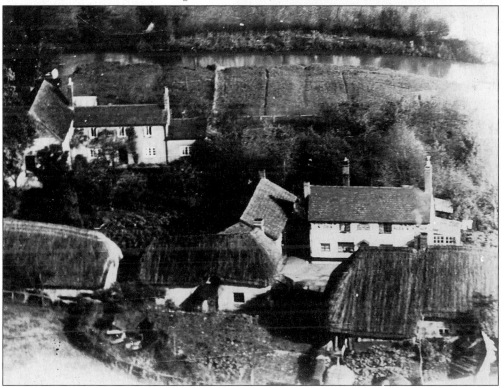

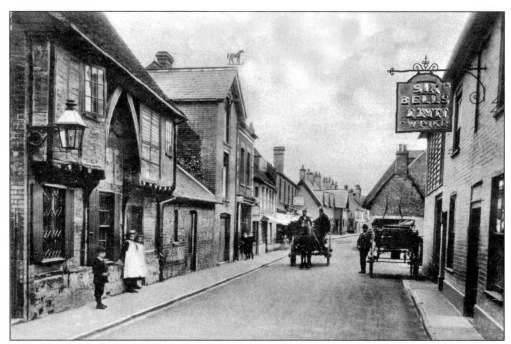

NORTH STREET, WILTON, BEFORE THE FIRST WORLD WAR. The Six Bells, on the right, is a very ancient inn which is still in business today. Many years ago it was owned by Folliott's Brewery of Salisbury. At the time of this photograph the landlord was William Pike. The building on the left is one of the oldest in the town and is believed to be of Tudor origin. Now a private residence, it once belonged to the Wilton Educational Charities.

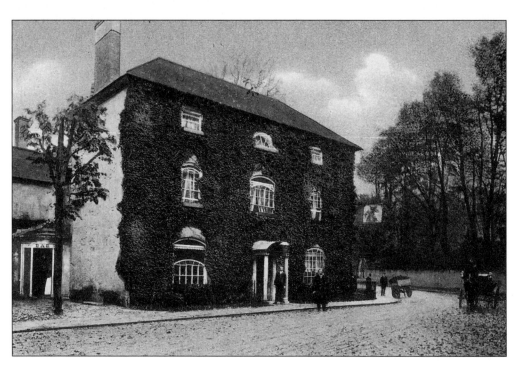

PREPARING FOR WAR! Pictured here are Cyril (left) and Len (right), the sons of William Jukes, a well-known Wilton printer, photographer and picture postcard publisher. The third person is Giggie Wootton. The photograph dates from very early in 1914, when the young men were already in the territorial army. They are practising signalling with a heliograph near the old reservoir along the track into Grovely Wood. By 13 August they were already in camp. Len went to France and Cyril to India. Fortunately they both returned to carry on their father's business in North Street.

Opposite: THE PEMBROKE ARMS, MINSTER STREET, WILTON. The inn was built of Fisherton grey brick in 1803. Kelly's Directory of 1865 states that flys (fast-travelling carriages) left from here with customers for Salisbury Station. It was also a posting house and an inland revenue office. This hotel replaced an earlier thatched inn, situated opposite, which had been demolished when the Earl of Pembroke had his estate enclosed.

33

ST JOHN AMBULANCE CADETS AT BARFORD ST MARTIN. The photograph records an occasion just before the Second World War. Pictured in the back row are, left to right: Mary Caines (1st), Mrs Rampton (3rd), Mrs Miller? (5th), Mrs Brown? (6th), Lawrence Bentley (8th), Ken Hibberd (10th) and John Lane (12th), who was later leader of the Downton Cadets. Middle row: Mrs Button (née Reeve)?, Harold Hounsome (2nd), Ms E. Battye (3rd) and Mrs E. Blythe (4th). Front row: Doreen Blythe (1st), Betty Caines (2nd), Dorothy Caines (3rd) and Gwen Whatley (5th).

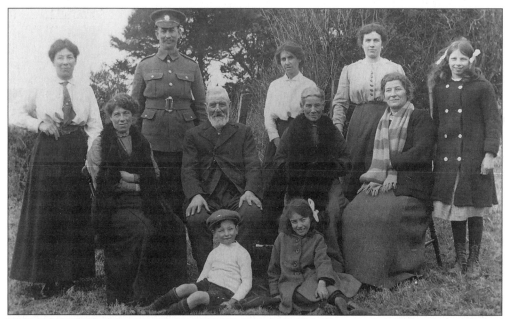

THE DAWKINS FAMILY OF BARFORD ST MARTIN. Harry and Ann Dawkins are seen here with a few members of their family. The photograph records the occasion of their Silver Wedding anniversary in April 1917. They had nine children: Sid, Mar, Harry (in uniform), Reg, Kit, Law, Newy, Roe and Alice (standing second right). Harry was a woodman. His wife Ann was the village midwife from 1905 to 1921 and much respected for her care.

A DINTON BEEKEEPER OF THE EARLY TWENTIETH CENTURY. Walter Lovegrove is shown here with his wife and daughter. They lived in Snow Lane. Old photographs of beekeepers in Wiltshire are scarce and they come to light very rarely these days.

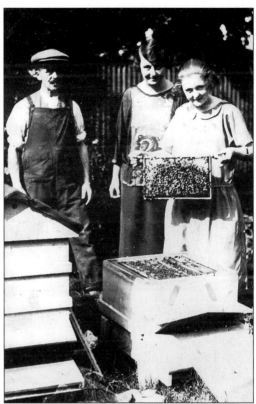

DINTON SCHOOL, AROUND 1904. The school was built in 1875 to accommodate 111 children but by the time of this photograph the building had been enlarged to take up to 200 children. Charles Maidment was the first headmaster and his wife Elizabeth was assistant teacher. A remarkable fact is that both had lost a leg and wore a wooden peg leg. They were said to be stern disciplinarians but very able teachers. When this picture was taken Mr and Mrs John Croome had taken over.

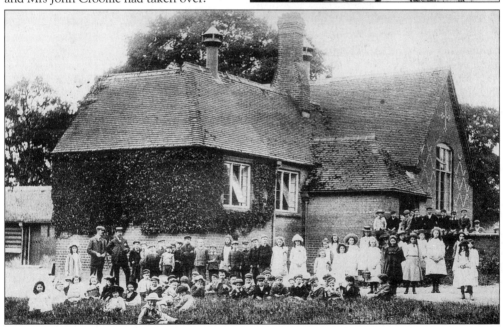

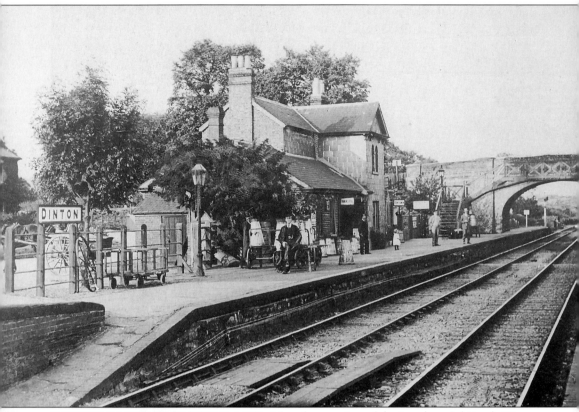

DINTON RAILWAY STATION, 1905. After the creation of the London and South Western Railway in 1859 Dinton provided the only station between Wilton and Tisbury. It gave a tremendous boost to the village economy. Local produce, including farm animals, fruit and vegetables were taken farther afield. The Wyndham Arms Hotel, situated next to the station, was built. This had extended stabling to accommodate the increased trade and farmers from the surrounding area often completed their journey to Salisbury Market by train. Children from the railway cottages would pick bunches of ox eye daisies for the engine driver and guard when shunting was taking place.

Opposite: THE WILTON HOUNDS AT THE BLACK HORSE, TEFFONT MAGNA. An earlier inn named the Black Horse was situated north of the village on a small country lane that was formerly the main toll road from Dinton to Teffont. With the creation of the new turnpike road through the village in the early nineteenth century, the licence passed to this building. It had previously been a farmhouse.

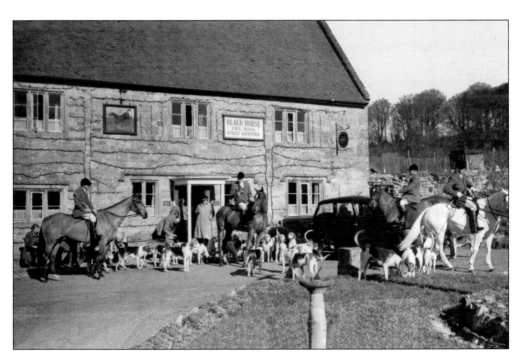

TEFFONT POST OFFICE AND GENERAL STORES, 1906. The shop lay opposite the Black Horse Inn. The lady shown is the younger daughter or sister of Catherine Jane Perrins, who married the store owner, William Thomas Brooks, on 28 May 1906. Aged 42, this was Catherine's second marriage. She subsequently became the village sub-postmistress. The picture was taken by William's uncle, Henry Brooks, who was among the earliest of Salisbury's commercial photographers.

CHILMARK SCHOOL IN EDWARDIAN TIMES. Situated in The Street, the school was built in 1861 but enlarged in 1895 to accommodate the growing population of around 115 pupils. It was run by the Seamark family from the 1860s to the early 1920s. William Seamark was the first headmaster with his wife Elizabeth as assistant teacher. Later their daughter, Christabel Grace, and their son, Edmund Arthur, taught here. The school is still functioning in 1997.

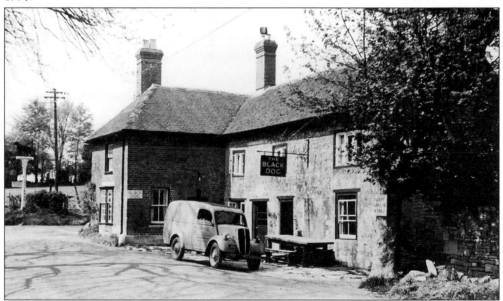

THE BLACK DOG INN, CHILMARK, IN THE 1930s. The village once boasted three inns. This is the only one remaining. It is an early eighteenth-century hostelry standing on the ancient toll road (B3089) which once took the stagecoach traffic through to the staging post at Hindon. The landlord from 1892 to 1942 was Harry Jukes. The van is a 10 cwt Ford operated by a firm from Bristol.

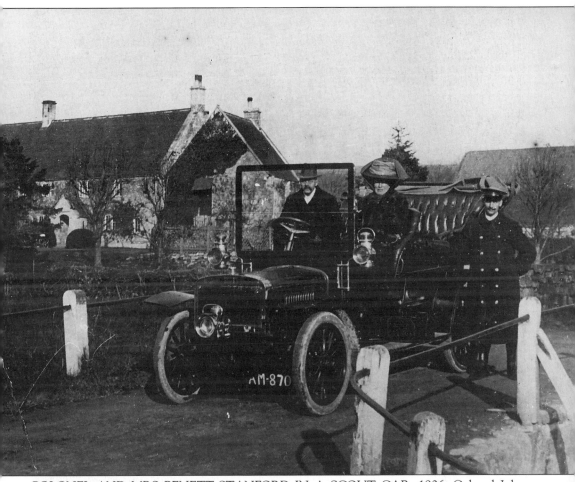

COLONEL AND MRS BENETT-STANFORD IN A SCOUT CAR, 1906. Colonel John Benett was known locally as 'Mad Jack' because of his eccentricity. He lived at Pythouse, Hatch with his wife Evelyn. They are seen on the bridge outside Place Farm, Tisbury, with the largest tithe barn in England just in view in the background on the extreme right of the picture. This side entry conveyance was the tenth motor vehicle built by the Scout Motor Company at their works in Friary Lane, Salisbury. Benett-Stanford never owned the car, however. This is a demonstration model kept by Joseph Percy Dean, Sales Director of the Scout Company. On 28 June 1906 the car was allocated the Wiltshire registration number AM-870. It was a 17/20 hp model with green painted body work, brass radiator, lamps and fittings and leather upholstery. The car has not survived.

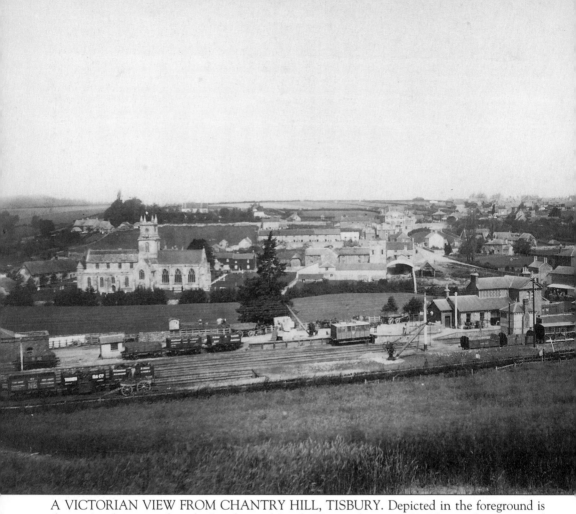

A VICTORIAN VIEW FROM CHANTRY HILL, TISBURY. Depicted in the foreground is the station that opened on the London and South Western line in 1859. The goods wagons and numerous other carts give some indication of the amount of commercial activity at that time. In the centre ground, by the tall tree, is a quantity of stone from the local quarries with a crane to transfer it to the wagons. The station master at the time was William Hill and the parcel agent was Harry Woods. The parish church of St John the Baptist dominates the scene but many other local buildings can be seen including the South Western Hotel on the left and the new Roman Catholic church on the right.

Opposite: THE SQUARE AT TISBURY DURING THE INTER-WAR YEARS. This is the scene at the bottom of the High Street with the road from the church and brewery on the left. The Benett Arms can be seen halfway up the hill and the post office is in the centre of the picture. On the right lies the shop premises of George Arthur Bull and Son, tailors and outfitters. The Bull family, with the Gethings and Walsh's, were shining lights in the dramatic society of the time. The lamp standard in the centre of the Square was recently replaced after a lorry had destroyed it.

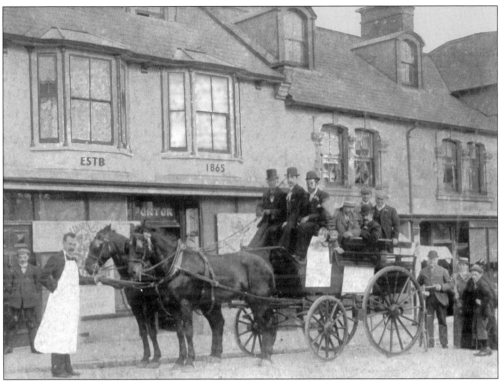

ELECTION DAY AT TISBURY IN 1900. There were two elections in the Wilton division in that year. J. A. Morrison of Fonthill Park was returned as Member of Parliament in both of them and retained the seat until 1906. Holding the horse's head is George Ponton, saddler and harness maker, who is seen here outside his shop in the Square.

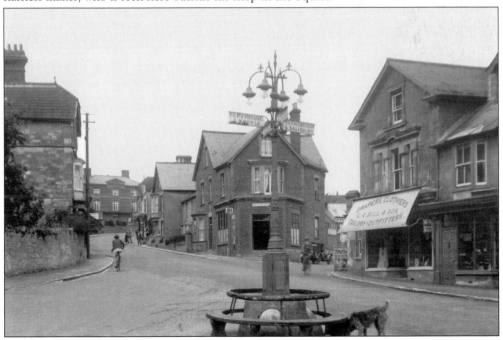

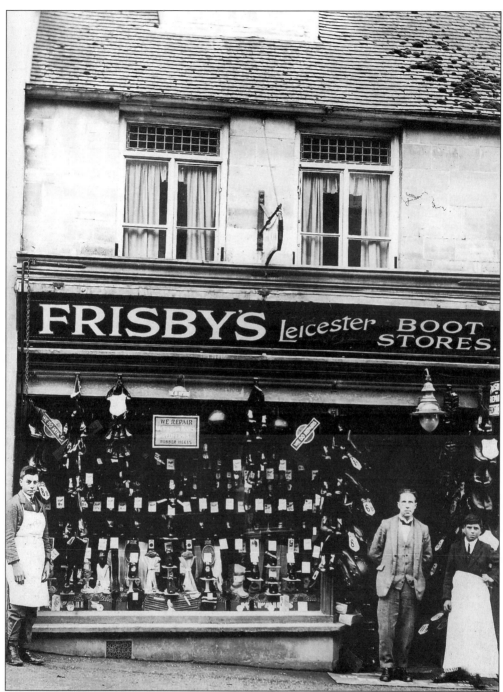

FRISBY'S BOOT STORES, TISBURY, IN THE 1920s. This shop in the High Street is the local branch of Joseph Frisby Ltd. of Leicester. Mr and Mrs Arlett were managing the shop at that time. Kathleen Mould, who still lives in the village, says, 'I always bought my stockings here for eleven pence three farthings and my best shoes at nine shillings and eleven pence.' Frisby's had many branches in the south including Warminster, Yeovil, Dorchester, Weymouth and Swanage.

Three
Wylye Valley

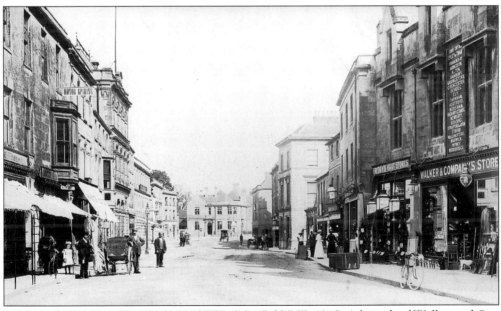

THE MARKET PLACE, WARMINSTER, IN AROUND 1915. A branch of Walker and Co., grocers, appears on the immediate right, with Frisby's, the Leicester boot stores, next to it. Further down the road is the town hall and the colonnaded front of the Old Bell Hotel. The post office can be seen in the centre. Evans and Son, the ironmongers, is on the immediate left.

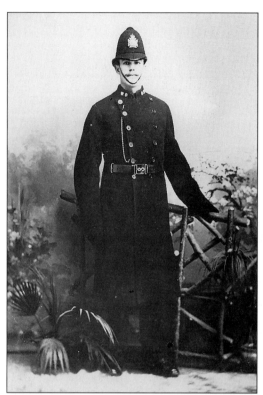

A WARMINSTER POLICEMAN.
PC William Whitlock was born in 1886 to the Pitton carrier Noah Whitlock. His career in the Wiltshire Constabulary started at Swindon, where he met and married Rosetta Mary Ann Halestrat. Their daughter Dulcie was born in 1916. He was later posted to Broadchalke and from around 1930 he completed his career at Warminster. He then became a security guard at Dent's Gloving Factory near the railway station. He died in 1967 aged 81 and was buried with his wife at the Minster Church.

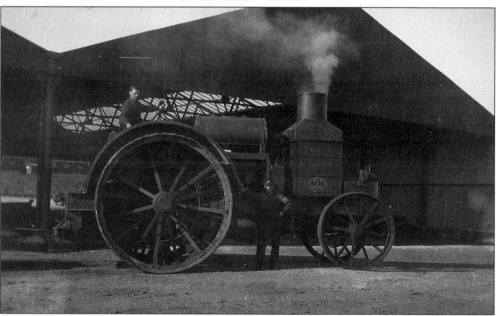

AN ARTILLERY TRACTOR AT WARMINSTER. Foster's of Lincoln built this monster, which had a Daimler petrol-driven engine. The tractor was used for general haulage and towing guns for the army. Its War Department service number was 18238. A large number of motorised vehicles were in use at Warminster Barracks. This particular machine was photographed while on service in the 1920s.

FORE STREET, WARMINSTER, 1915. Ernest Dodge's bakery was situated on the corner. It was also a post office and a confectioners at that time. Mr Dodge is believed to be the man standing by the horse-drawn van which has loaves of bread on top. The horse is tucking into a good meal of oats. The original of this photograph is very faded and in a terribly poor condition. The print has been scanned into a computer, digitised, and the detail and contrast enhanced. The photographer of 1915 would be even more amazed than we are at what technology can do with his creation some eighty years later.

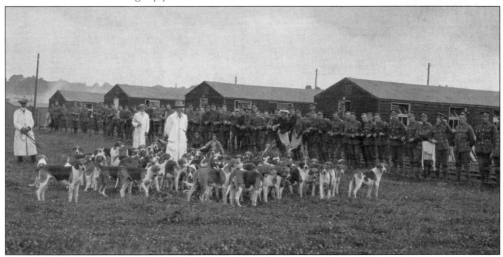

TOMMIES ADMIRE THE FOXHOUNDS AT SUTTON VENY CAMP. The hounds are believed to be from the South and West Wiltshire pack. The soldiers' hutted accommodation in the background had only recently been erected when this photograph was taken by Mr Vowles in October 1915. Some underwear can be seen hanging over the fence to dry!

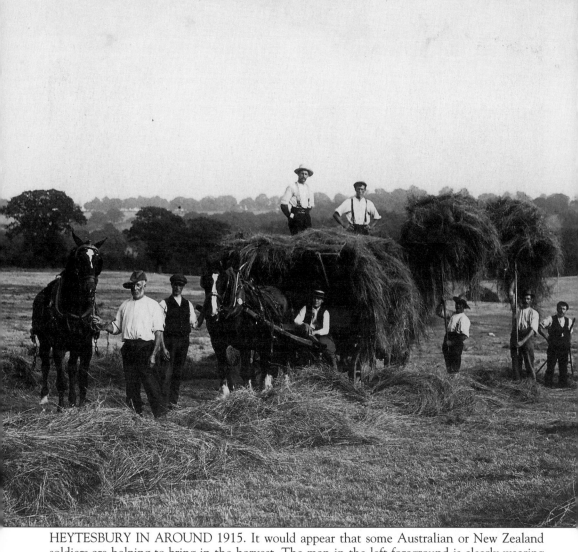

HEYTESBURY IN AROUND 1915. It would appear that some Australian or New Zealand soldiers are helping to bring in the harvest. The man in the left foreground is clearly wearing Australasian headgear. There were at least six farms at Heytesbury at the time. This is believed to be Mill Farm, run by Albert Charles Parrott. Siegfried Sassoon, the war hero and poet, lived in this village.

Opposite: A PASTORAL SCENE ON THE PLAIN, a very unusual picture. Salisbury Plain was more commonly associated with sheep than goats. This particular herd are believed to have been photographed at Imber in around 1880. The road appears to be the one leading to Heytesbury. There are two people shown. The goat herder stands in the middle of the road and in the distance a cyclist can be seen riding a three-wheeled Velocipede (an earlier type of cycle).

THE VILLAGE OF HEYTESBURY IN 1916. The original picture postcard was sent to Mrs Lena Taylor in Stratford, East London, from a soldier at Heytesbury Camp. It was sent on 4 August at 8.35pm, 'Dear Lena, have just come off church parade. This sounds strange if you notice the time of day. We have just had a special service commemorating the end of the second year of war. Love and kisses from "A".' On the right is the Angel Inn, where Aubrey Tanner was the licensee.

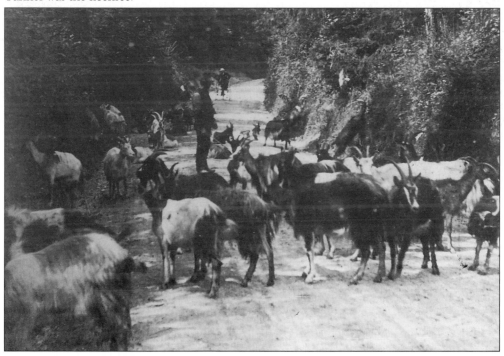

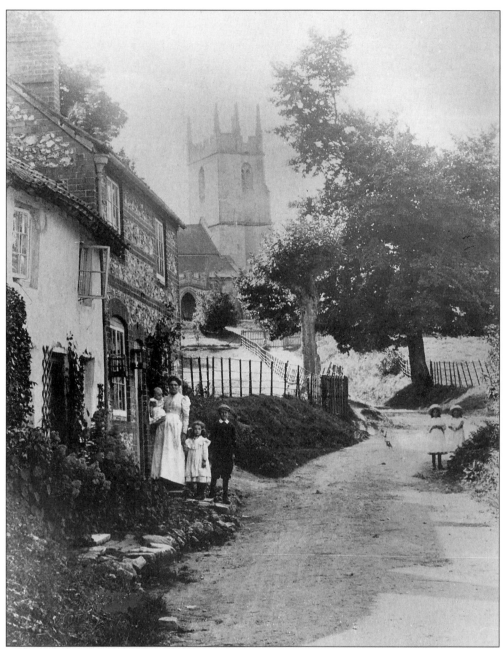

THE VILLAGE OF IMBER, BEFORE 1909. Here we see the road leading up to St Giles' Church. The Ruddle family are standing by their cottage which has lark cages hanging outside the front door. On the right are the Carter twins who are just setting off to school. Although the church remains in good condition, these cottages, like most of the others in the village, have now disappeared. Imber church tower is unusual in having five pinnacles instead of four.

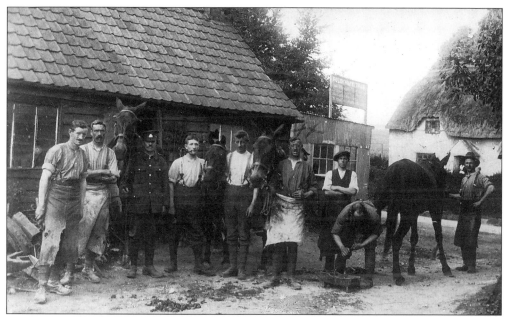

THE CHITTERNE BLACKSMITHS, 1915. William James Feltham started business here with his cousin Clement Polden as carpenters and wheelwrights in 1878. Their premises were situated near the churchyard and the business continued until 1977 when the last members of the family to run it were Owen and Alban Polden. The soldiers and military farriers in the picture appear to be shoeing mules as well as horses.

BRIDGE GARAGE AND THE KING'S HEAD AT CHITTERNE, 1962. Graham and Linda Dean's garage and guest house are shown on the right with the King's Head in the distance. A message on the back of the original picture postcard was written by a holiday group who referred to themselves as 'the travelling trio'. They stayed in the first floor bedroom (extreme right) of Ye Old Bridge Cottage. They described the experience as 'a holiday to be remembered!'

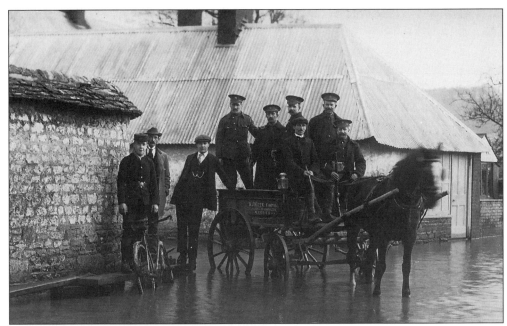

CODFORD ST MARY IN THE FLOODS, JANUARY 1915. This was the scene at the junction of Chitterne Road and the High Street. The wet weather conditions of that winter were the worst in living memory. Many of the soldiers bivouacked on the Plain suffered dreadfully. At Codford the Chitterne Brook often overflowed in stormy weather causing flooding. Here we can see a group of soldiers with William John Mizen, the village carrier who ran the Salisbury and Warminster service. On the left of the group is a local telegraph boy who would have been kept very busy at the time of the Great War.

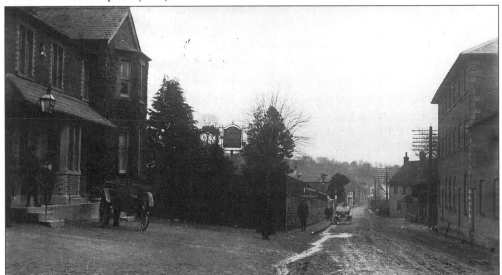

HIGH STREET, CODFORD ST MARY, AT THE TIME OF THE FIRST WORLD WAR. We are looking east and the George Hotel is on the left. It had been rebuilt further back from the road in around 1900. Opposite can be seen the Wool stores that were later to be used as a theatre and as an American army recreation centre during the Second World War. It is still used as a theatre today.

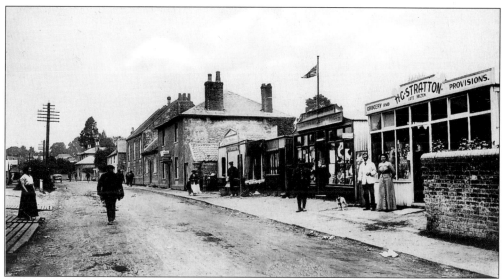

HIGH STREET, CODFORD ST MARY, DURING THE FIRST WORLD WAR. The temporary buildings that can be seen to the right provided shops and other services for the troops who were encamped around this area of Salisbury Plain. H.G. Hatton owned the grocery and provision store shown in the foreground. It had previously belonged to William John Mizen, the village carrier. The first brick house further along had been converted into a bank by the time of this picture. Other shops along the High Street at that time would have included Hardy's Grocery Store, G. Rogers and Co. (ironmongers and house furnishers), and Couzens' Stores.

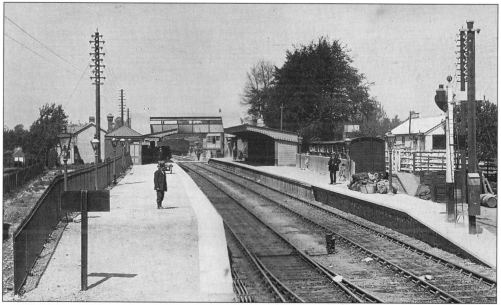

CODFORD STATION, 1900. The railway line between Salisbury and Warminster was completed in 1857. It was originally a single line with passing loops added in ensuing years. As traffic increased this method proved inadequate and the line was doubled – as can be seen in the picture. The level crossing, signal box and covered footbridge come into view at the end of the platform. The station closed for passenger traffic in 1955 and for goods in 1960.

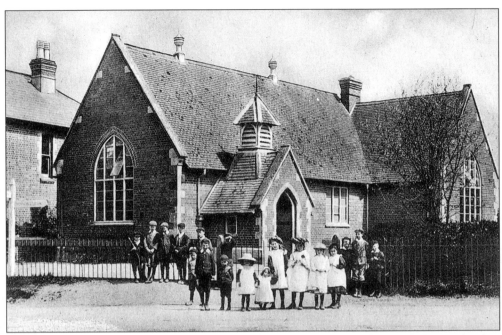

WYLYE SCHOOL, 1904. Built in 1876, this school was enlarged in 1893 for the needs of 93 children and given an adjoining house for the schoolmaster. The master at that time was Job Wootton. The school has been a private residence since the early 1970s. The picture postcard was written by a South Australian to his mother at the time of the First World War.

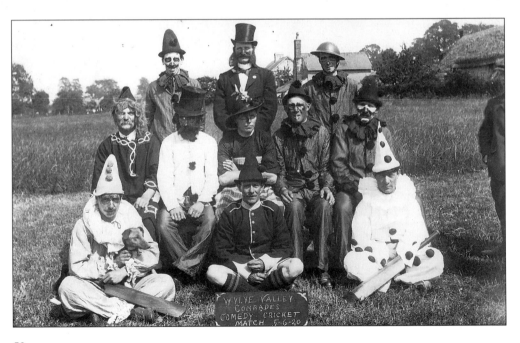

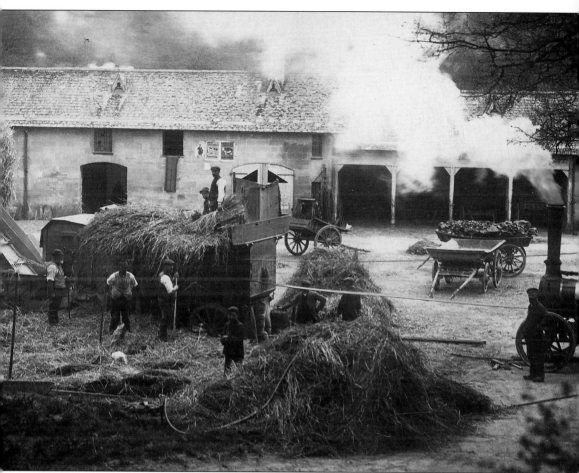

LITTLE LANGFORD FARM IN 1910. This view of the rick yard is little changed today. Despite the early date, this farm appears to be well mechanised. The threshing machine is driven by a belt attached to the steam traction engine shown on the extreme right of the picture. Nicholas Helyer comments that his family took over the farm from the Andrews family in 1940. The threshing drum was still working then and kept going until well into the 1950s. Thomas Wallace was the engine driver and Bert Noyce operated the drum feeder. John Foot is the young lad standing in the foreground. Ted Inkpen is thought to have been the farm manager who lived in the bailiff's house which looks down on the yard.

Opposite: WYLYE VALLEY COMRADES' COMEDY CRICKET MATCH, 5 JUNE 1920. Two of the characters featured here are dressed in Pierrot costume. The man in the middle of the front row appears to be wearing a military tunic and a wizard's hat. Among the individuals in the second row are two minstrels with blackened faces. They were all popular characters of the time.

JOSEPH 'JESSIE' GURD. At one time head groom at the Larmer Tree Gardens, Tollard Royal, he became landlord at the Bell Inn, Steeple Langford, with his wife and daughter Marjorie. He later moved to the Royal Oak at Great Wishford.

STEEPLE LANGFORD IN THE 1950s. A scene showing the A36 Salisbury to Warminster road. A Wilts and Dorset bus, parked outside the Bell Inn, is on route to Salisbury. By the 1970s this had become a very busy thoroughfare. With the construction of the A36 bypass, the village has returned to its former tranquillity.

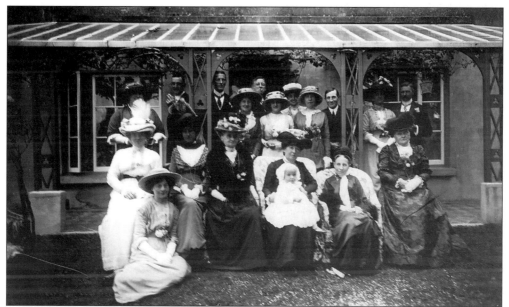

'AUNTIE IVY'S WEDDING' AT STAPLEFORD, 9 JULY 1913. A hand written note on the back of the original picture names several members of the party: Grannie Seaward, Granny Gay (with baby Peggy on her lap) and 'mother' in the middle row left. Notice the wonderful array of festive hats! With the shadows of war gathering, it was the end of an era. Soon army camps would be disturbing the rural calm of the Wylye Valley.

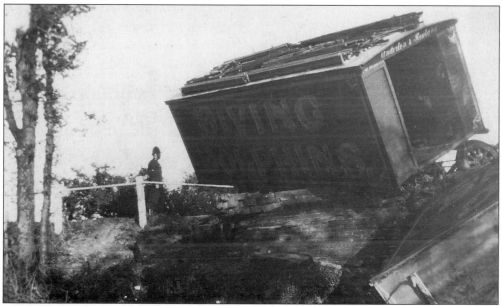

AN ACCIDENT NEAR STAPLEFORD, 24 OCTOBER 1929. A steam engine was towing a living van and two Anderton and Rowland's wagons as this particular fairground ride moved from Salisbury to its base in Bristol. The driver lost control of the traction engine and the wagons broke loose and crashed. The living van thankfully stayed upright and a woman and her baby had a very lucky escape. The Scenic Diving Dolphins was not one of the most popular fairground attractions and the 1929 season was the only year in which it travelled.

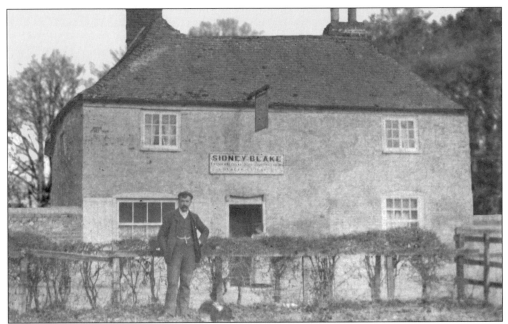

THE BELL INN, SOUTH NEWTON, 1905. At the time of this photograph Sidney Blake was the landlord. He was licensed to sell wine, beers, spirits and tobacco on the premises. He was also a local farmer. A trade directory of 1890 lists a previous landlord with the unusual name of Green Peace.

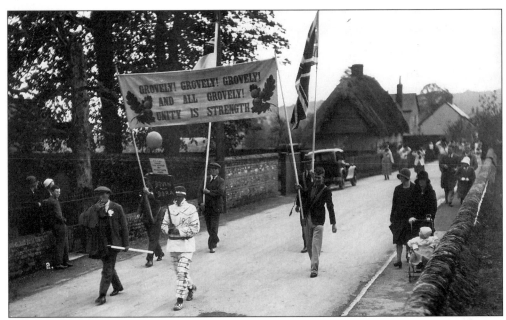

OAKAPPLE DAY CELEBRATIONS AT GREAT WISHFORD, 29 MAY 1938. The annual festivities had commenced at 5.30am when villagers were roused from their beds by the banging of dustbin lids, tin cans and the ringing of bells. The picture shows the annual procession passing through the village, headed by a banner which bears its ancient slogan, a reminder of the villagers' rights to gather firewood in Grovely Wood.

Four

The Till Valley

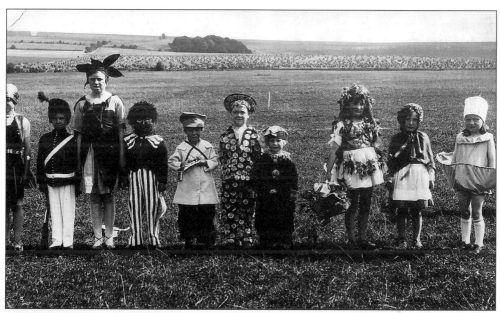

THE CHILDREN OF MARKET LAVINGTON. This group of youngsters were photographed during Hospital Carnival Week in August 1928. The event was held annually in the recreation ground for the purpose of raising funds for local hospitals. The secretary at that time was Bill Drury. Pictured left to right are Bessie Gye, Tom Gye, Lill Drury, John Drury, three unknown individuals, then Peggy Welch and Phyllis Hatswell. Tom Gye and Peggy Welch were later to marry.

JOHN HAMPTON MERRITT, THE MARKET LAVINGTON BLACKSMITH.
The Merritts had plied their trade in the village for generations. Their shop was originally to be found in Northbrook but in the early nineteenth century it moved to White Street. Born in 1841, John Merritt had two sons. Tom carried on the blacksmith business whilst John (junior) developed a cycle and car hire outlet in Church Street. He also became a local celebrity, being bandmaster of the Market Lavington Prize Silver Band, the members of which practised in a cow shed in White Street. When John junior died he was reputed to be the oldest bandmaster in England. This carte-de-visite photograph was taken by Albert Burgess, who came to the High Street in the 1880s.

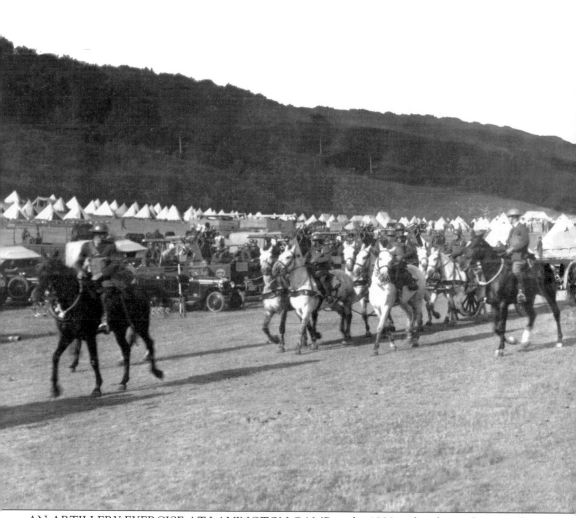

AN ARTILLERY EXERCISE AT LAVINGTON CAMP in the 1920s, when horse-drawn and mechanised forces were working side by side. This is clearly a temporary camp as a large number of bell tents are to be seen in the background. A horse-drawn gun and limber are crossing in the foreground and in the middle distance a number of motor trucks are parked. Among them are several Crossley tenders and at least one vehicle which would seem to be designed for use in rough terrain. It has the characteristics of a British-built Crossley gun tractor to which have been fitted a pair of Kegresse half-tracks. These machines were popularly known as Dragons.

Opposite: MARKET LAVINGTON PRIZE SILVER BAND, NOVEMBER 1947. Taken in the grounds of Beech House in White Street, the picture shows Aubrey Chapman and Mr Sainsbury among others in the back row. Bill Perry stands seventh from the left in the second row. In the third row can be seen Tom Merritt (1st), George Pike the butcher (4th), John Merritt the bandmaster (5th) and Bruce Gale (6th). The players came from Market Lavington and surrounding villages. The band won many trophies.

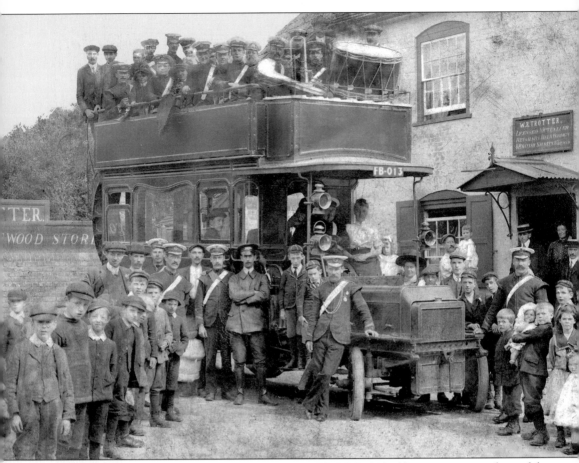

A MOTOR OMNIBUS AT MARKET LAVINGTON IN 1912. About twenty members of the Market Lavington Prize Silver Band have turned out on the upper platform of this double-decked conveyance from the Bath Tramways fleet. The vehicle's registration number is FB-013, which is rather unusual in having a nought inserted before the index number 13. This was a peculiarity of the Bath motor taxation authority. The vehicle is thought to have been one of a batch of six similar machines (FB-008 to FB-013) that were made by the German Büssing company in 1905. Imported by the agent, Sidney Straker & Squire Limited of Fishponds, Bristol, the six 35-seater buses were delivered to Bath Tramways Limited from August of that year. The scene is set outside the Volunteer Arms public house of which William Robert Trotter was the registered inn keeper from around 1910 until the late 1930s. By 1939 Miss Ivy Victoria Trotter was the licensee. The inn closed in 1990.

Opposite: TRACTION ENGINE CRASHES ON LAVINGTON HILL! At around the time of the First World War this Fowler Lion road locomotive was travelling the road from Bulford to Lavington Station carrying a military consignment. As it descended the hill at West Lavington, the brakes failed. The ungainly vehicle went out of control and its pair of wagons overturned depositing the load halfway down the hill. The Lion class of traction engine was introduced in 1911. Many of them were supplied to the War Department.

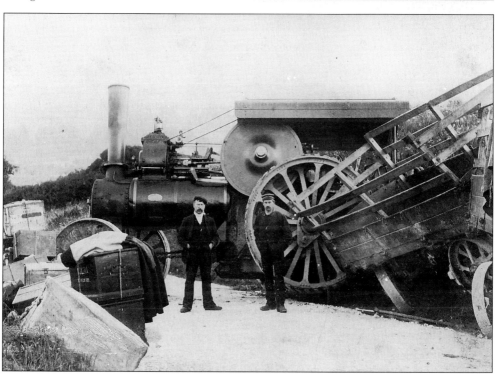

OLD PALS TOGETHER! During the terrible winter of 1914-15, Canadian troops living in tented accommodation on the ridge above Market Lavington were transferred to billets in the village. They soon made many friends. Two of them can be seen here with Norman Neate, the landlord of the Brewery Tap Inn in White Street. Neate was the last innkeeper in the village to brew his own beer. The pub was converted into two cottages in 1924.

THE BRIDGE INN, WEST LAVINGTON, BEFORE 1885. Enos Bartlett was the landlord at the time of this photograph. The five cottages on the right of the Devizes Road are now tiled but a fire recently revealed the old thatch beneath. Behind the wall on the immediate right is Dial House, which is believed to be haunted by a lady. An ancient track, Rutts Lane, passes the house and goes up to the downs. It is named after 'Mistress Rutt', a member of the Sainsbury family who were benefactors of Market Lavington. Perhaps it is her ghost that now haunts the house!

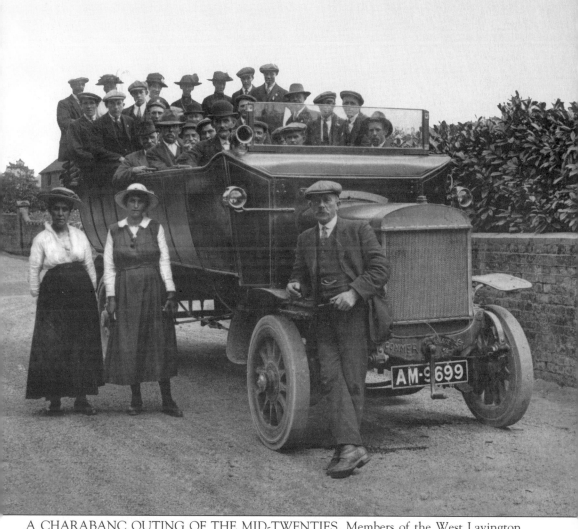

A CHARABANC OUTING OF THE MID-TWENTIES. Members of the West Lavington Branch of the Workers' Union are about to set off on a day trip to Trowbridge. We believe that the passengers were going to attend a political rally. Their conveyance was a Commercar charabanc from the Lavington and Devizes Motor Services fleet that was started by Fred Sayers in 1911. Fred had his house, garage and repair workshop at the Market Lavington Market Place on a site previously owned by the local doctor. He sold out his business to the Bath Tramways Company in the 1930s. The vehicle is pictured here at the Market Lavington crossroads, with Dauntsey's School on the right.

Opposite: ALL SAINTS CHURCH, WEST LAVINGTON, BEFORE 1885. The church looks much the same today although the 'spirelet' has been removed and a war memorial is now situated in the foreground. The shop to the left was at one time the post office and general store of James Mead who also collected the tithes for the vicar. He was also the poor rate collector and agent for the Sun Alliance Insurance Company. When Richard Wilkinson of Trowbridge produced this carte-de-visite photograph, the Revd Arthur Baynham was vicar of the parish of West Lavington. He had been resident in the village since 1873.

THE BELL INN, TILSHEAD, EARLY IN THE TWENTIETH CENTURY. The landlord at that time was Ernest Witt who was born in 1874. He is shown here outside the pub with his family. Left to right: Leslie (born 1902), an unidentified old man, Ernest Witt with his son Roy in front (born 1908), Clifford (born 1904), and Bessie his wife. The inn was situated on the left of the road going towards Devizes. Now a private residence known as Bell Cottage, it is believed to be the oldest house in the village.

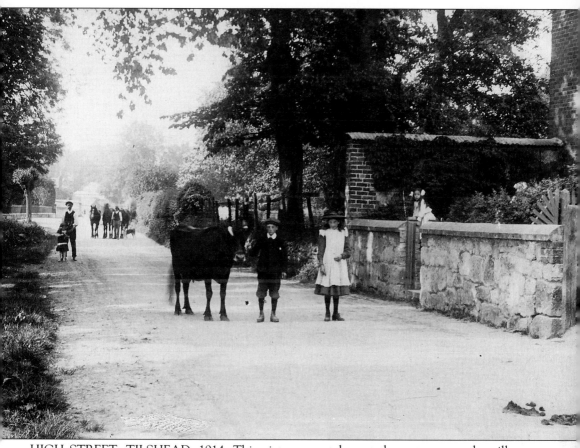

HIGH STREET, TILSHEAD, 1914. This picture was taken at the entrance to the village coming from Salisbury. Out of view to the left is Pembroke Farm. The house on the right is May Villa, a plaque upon which informs the reader that it was built in 1901. An old inhabitant described Tilshead at that time as 'poor, but having many horses'. You can see some of them farther along the road.

Opposite: TILSHEAD AT THE DAWN OF THE TWENTIETH CENTURY. On the right is Thomas Long's bakery and grocery store. Mr Long was a familiar figure pushing his wares around the village in little more than a box on wheels. He also owned the village mill which was situated behind his shop. Dean and Chapter Farm can be seen down the road on the left (the middle thatched house). It was run by the Lawes family. The post office, run by Samuel and Gladys Lawes, lay to the left of the farm and is obscured in the picture. The photographer has gone to some lengths to add interest to his creation.

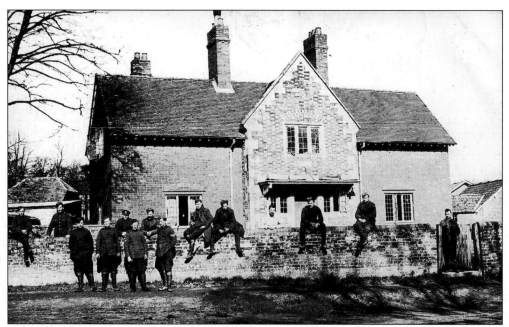

DRAX FARM, TILSHEAD, AT THE TIME OF THE FIRST WORLD WAR. This building is situated opposite the present post office and shows numerous soldiers from Tilshead Camp enjoying a moment of idleness. The Drax family had owned land at Tilshead since the sixteenth century. In the inter-war years, however, the resident was Allan Havelock-Allen a local magistrate. During the Second World War it provided a tea room for the troops when the British Legion hut was burnt down.

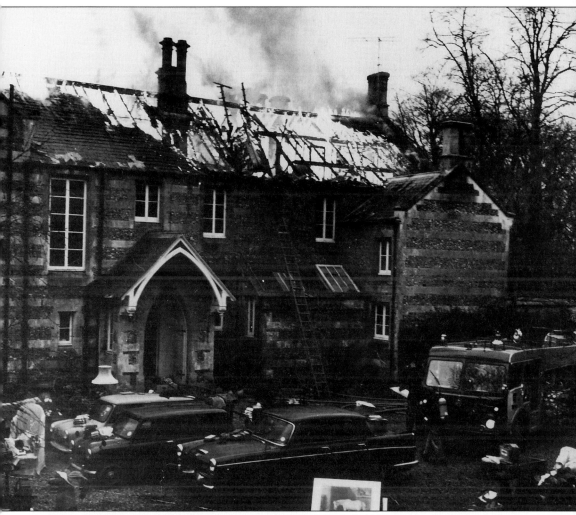

A FIRE AT STURDY'S FARMHOUSE, ORCHESTON, LATE 1960s. Richmond Sturdy lived here with his sister Heather. He was a breeder and trainer of race horses. A wedding was to take place in Shrewton the next day but the vicar did not turn up for the rehearsal the previous evening because he felt it more important to tender his pastoral assistance at the fire. While the property was being restored the Sturdys went to stay at Shrewton House with Lady and General Hinde. The Bedford-HCB fire appliance in the right foreground (EMW 684D) has arrived with a crew of fire-fighters from Amesbury.

Opposite: THE EARLIEST KNOWN PHOTOGRAPH OF THOMAS A BECKET CHURCH, TILSHEAD. The view at that time was much more open. This picture was taken by the vicar, Reverend Joseph Holden Johnson, before the lyke-gate was added. He was curate and vicar there for sixty years until his death in 1884. At that time he was one of the oldest surviving members of the Church of England. A local poet of the time wrote of Mr Johnson, 'a cleverer man than Passon is there yent in the world beside, and many a thing he've a-tried to do, and he've done everything he've a-tried'.

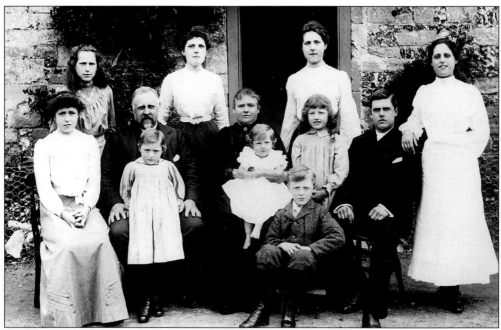

THE HALL FAMILY OF ORCHESTON IN 1905. John Hall was the landlord of the Crown Inn, outside which the family were photographed. Standing left to right are Annie (married Rupert Dyer), Mary (married Mr Durley, a sailor), Ruth (a nurse who married an Irish major) and Agnes (married Louis Chant, the Shrewton baker and grocer). Seated are Betty, John (the landlord) with Ellen on his lap, Martha his wife with their youngest son John, who is wearing a dress, Margery (married Charlie Sparrow, a Salisbury coach proprietor) and Clifford. Henry is sitting in front of the group. Clifford and John operated Orcheston's first bus service, which the family started in around 1910. Their first buses were supplied by the Scout Motor Company of Salisbury. They were garaged at the Crown Inn.

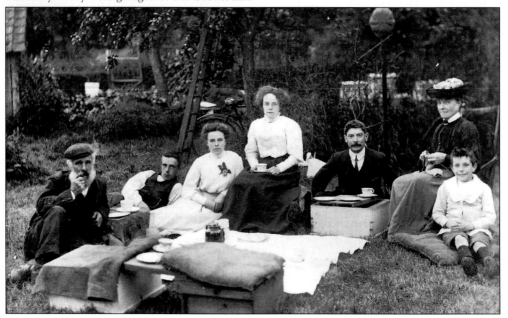

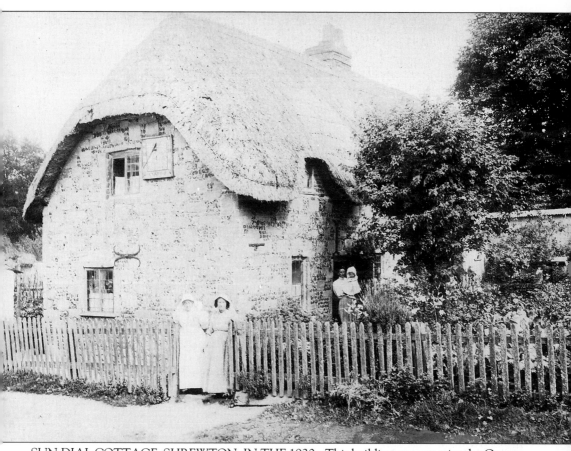

SUN DIAL COTTAGE, SHREWTON, IN THE 1920s. This building was opposite the George Inn going towards Larkhill. It pre-dates the present Sundial Cottage, which was built on the same site. This was the home of Edward Lovelock, who worked at the Shrewton Steam Laundry for more than forty years. Pictured in front are his sisters Eadie and Millie. Standing at the door is his wife Edith with their baby John who still lives in the village. The sun dial can be clearly seen on the end wall of the cottage.

Opposite: THE MAY FAMILY AT SHREWTON, 1910. Albert Feltham Marett is pictured here with his wife Annie and her family, the Mays. They lived at Brookside, which stood near the village lock-up. Albert was a commercial photographer who took many photographs depicting life on Salisbury Plain from 1909 to 1916. Pictured left to right are Tom May (Annie's father), Will May (her brother), Amy May (her sister), Annie Marett (née May), Albert Marett and Lydia May (her mother). Who is the boy at the end?

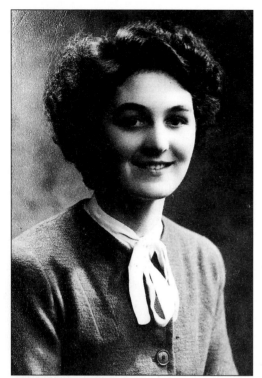

JOAN WITHERS (NEE MARSON). Joan was born at Derby in 1926 but left there to join the Land Army during the Second World War. She worked on G.R. Smith's farm at Rollestone where she met Harry Withers following his return from service with the RAOC in 1947. Following their marriage they continued to live at Shrewton for forty-six years until her death in 1996. The Withers family has made a great contribution to the area. Harry's grandfather, Reuben, came to Shrewton in 1880 from Wylye as publican at the Wheatsheaf. The family continued to farm at The Fleming, where they also had a milk and coal delivery business which Harry ran with his brother John.

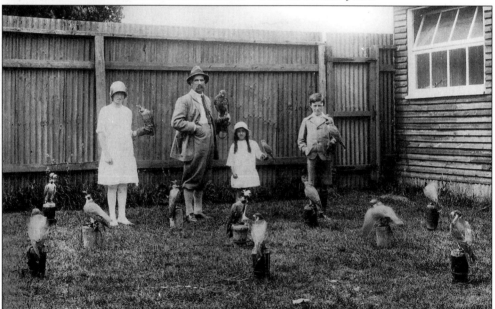

THE OLD HAWKING CLUB AT SHREWTON IN 1929. Richard Best is pictured here with his children Doris, Gladys and Ronnie. He was a falconer employed by the club. He lived in a white house called Homeleigh in Maddington Street. Following a fire the birds were being kept at the school field which is where this picture is believed to have been taken. The Old Hawking Club specialised in flying peregrines. Shrewton was its winter quarters. When it was disbanded it had been in existence since 1890 as a private invitation club of ten to twelve members.

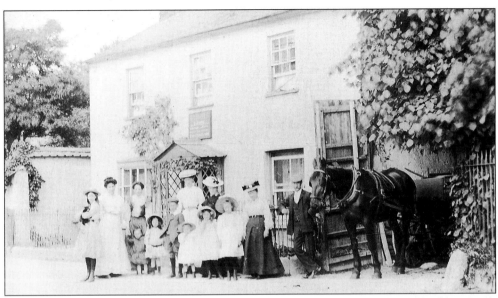

THE HOME OF THE SHREWTON CARRIER. Charles William West is pictured here with his family in the premises next to the church. This was their home from around 1906 to 1910. Charles travelled to Salisbury Market on Tuesdays and Saturdays each week and to Devizes on Thursdays. In later years this shop was run by Herbert Bundy, whose brother kept the Plume of Feathers opposite. Herbert ran a newspaper business from here, cycling to Great Wishford for the papers which, Gwen Coles says, 'we were lucky to receive by the middle of the afternoon'.

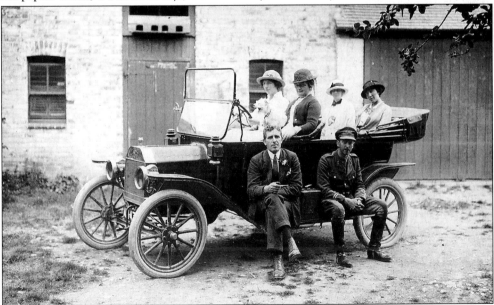

THE DOCTOR'S CAR AT SHREWTON IN 1915. Pictured here is a black Model T Ford four-seater belonging to Dr Robert Frederick Charlton Hall. It was allocated the number plate AM 4363 at Trowbridge on 7 December 1914. Charlton Hall was the village doctor and the Medical Officer for the Amesbury Union. He is believed to be the man sitting on the front of the running board. His house, St Elmo, stands near Bridge Garage with the River Till running at the side. The photograph was taken in front of the stable area at the rear of the house.

LOUIS JAMES CHANT. Louis was born in 1884 and worked in his grandmother's bakehouse. He joined the Wiltshire Yeomanry in 1909 and his bugle is still kept by his daughter Gwen Coles. In 1914 he married Agnes Hall and later took over the Crown Inn at Orcheston (see page 68). It was a double wedding with her brother Clifford. It was also the first in the village at which the bride arrived by car. Louis died in 1966 when he was 82 years of age.

THE EARLIEST KNOWN PHOTOGRAPH OF SHREWTON. Believed to have been taken in the 1870s, this view features Salisbury Street with 'Aunt Mary's' grocery and confectionery shop on the extreme left. Most of the thatched cottages shown here have gone. A woman can be seen crouching in the centre of the picture with two children, one of whom would seem to be seated in a three-wheeled invalid carriage. It would also appear that the woman is pointing at the photographer and instructing the child to 'Watch the Birdie'.

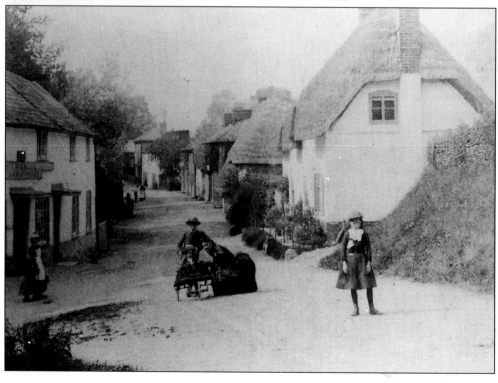

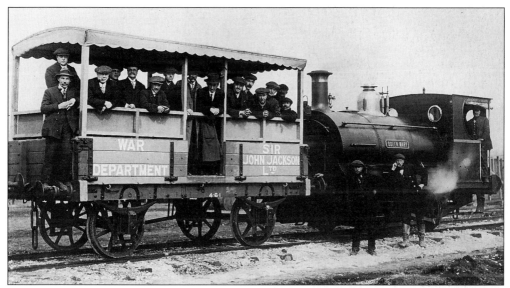

THE *QUEEN MARY* AT THE TIME OF THE FIRST WORLD WAR. This 0-4-0 saddle tank locomotive was one of several engines operated by Sir John Jackson, one of the largest public building contractors in the country. At Larkhill, for example, his company constructed the longest War Department military railway on Salisbury Plain. The firm also constructed much of the hutted accommodation there. The picture was taken by William 'Bill' Ross, a professional photographer who was based at Shrewton.

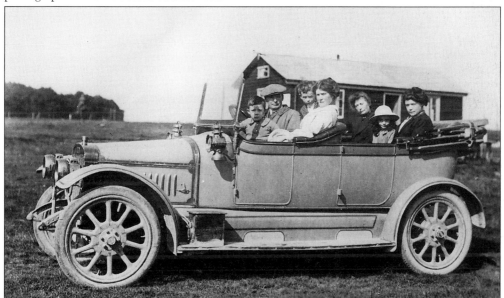

'A TRIP TO AUNT WINN'S' IN THE 1920s. Winifred Brown lived in this wooden hut near Rollestone Camp. Paying her a visit are her two sisters, Miss Castle and Mrs Alford. Seated in the car with them are Archie Musselwhite, Kenneth Alford, Gertrude Musselwhite, Rosina Castle, Madge Goodyear and Mr Alford's mother, Georgina. The car (AM 6205) is a french grey coloured 15.9hp Colonial model built at the Scout Motor works in Churchfields Road, Salisbury in 1916. It was owned at first by Samuel John Jennings, builder, of 6 Wilton Road, Salisbury.

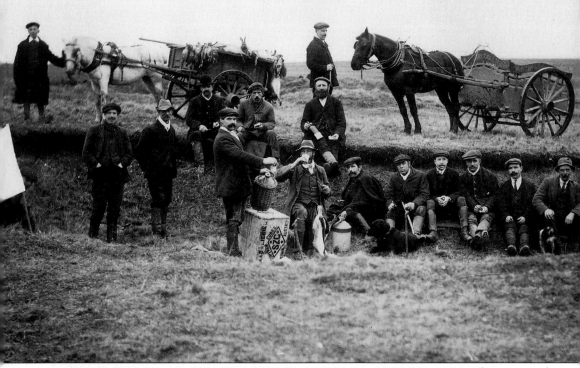

A GAME SHOOT AT WINTERBOURNE STOKE IN AROUND 1916. The group of agricultural labourers sitting in the foreground are taking a refreshment break. Mr Barnett is seated second from the left and Mr Bolton second from the right. Third from the left is Ollie Withers. The cart shown on the left of the picture appears to be well laden with game as numerous birds and a hare can be seen. The gentleman standing alone in the centre background would appear to be Cary Coles of Manor House Farm (where this shoot is taking place). The second cart has been attractively sign written with the words 'Cary Coles, Winterbourne Stoke.'

Five

The Avon Valley

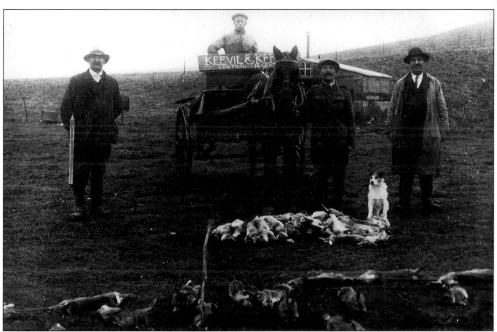

RABBIT CATCHING ON THE PLAIN. For many years Charlie Andrews had the sole rights to catch rabbits in and around his home at Upavon and on parts of Salisbury Plain. In the 1920s and '30s Upavon provided London and Southampton with vast quantities of rabbits. They were transported by train from Woodborough Station. Pictured here, from left to right, are Bill Osborne, Tom Andrews (on the cart), 'Farmer' Bailey and Charlie Pinchin. Keevil and Keevil were the agents for the London markets.

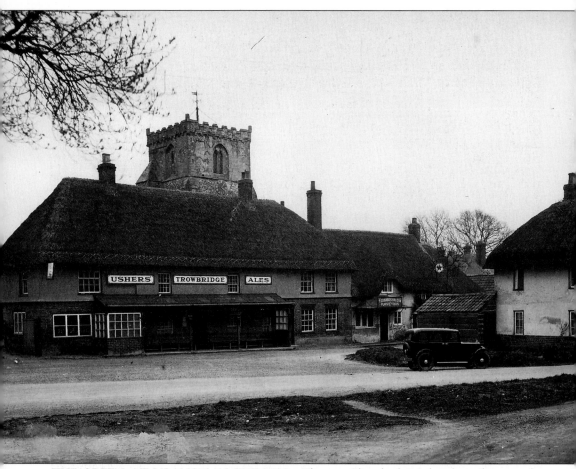

THE GREEN AT UPAVON IN THE 1930s. Thomas Chamberlain's butchers shop can be seen to the right of the Ship Inn and the crenellated tower of the parish church of St Mary is in the background. The church has long been the home of jackdaws, which is perhaps the reason local inhabitants who are born in the village are known as 'Jacks'. The white cottage on the extreme right was demolished many years ago. Parked in front of it on this particular occasion is a 1932 Morris saloon motorcar (WV 1359) owned by William R. Hamblett, an insurance agent, of 5 The Crescent, Pewsey. The glory days of RAF Upavon, the birthplace of the Air Force, are now over but the refuelling of flights during the Falklands' Campaign was masterminded from here.

Opposite: HOSPITAL SUNDAY AT NETHERAVON IN JULY 1907. Treatment at Salisbury Infirmary could only be obtained through the purchase of In-patient and Out-patient Orders. A supply of these was necessary for the poor and needy and funds had to be raised. The banners of the local friendly societies and members of the village band are to be seen at the head of this procession. One or two Wiltshire policemen also appear to be mingling in the crowd.

ENFORD AT THE TIME OF THE FIRST WORLD WAR. We are looking east towards Enford Hill. A man with a scythe appears to be standing in the road with the thatched post office to his right. The Salisbury Road is passing in front of it. Although Enford means the duck ford, a swan will be seen on the sign of the public house in Long Street. This lies in the far distance to the right. Enford is a peaceful village made up of three hamlets grouped around an ancient crossing place – today you will find a bridge for your convenience.

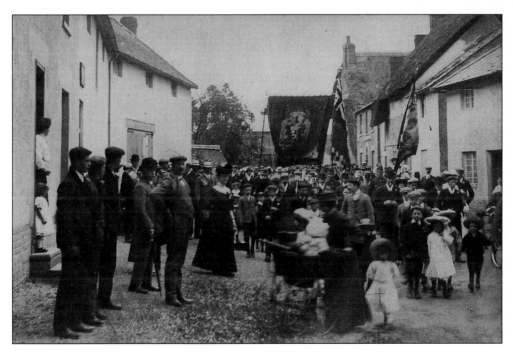

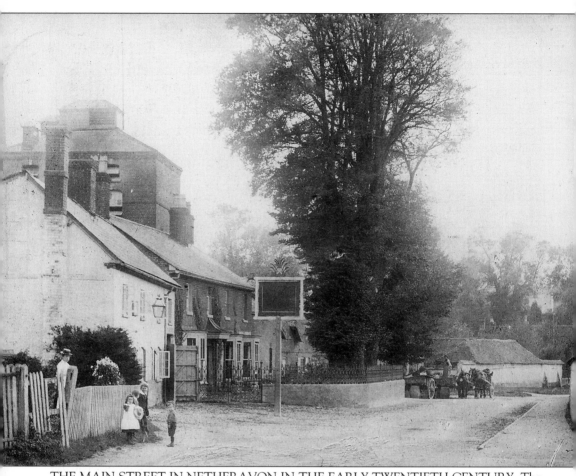

THE MAIN STREET IN NETHERAVON IN THE EARLY TWENTIETH CENTURY. The Fox and Hounds Inn can be seen on the left with a brewer's dray and a coal wagon parked in front. Tom Salter was the landlord at the time. Coming into view behind the inn is the imposing edifice of Thomas Whiting Hussey's Brewery which was largely demolished later in the century. What remains is now a warehouse used by a local builder.

Opposite: THE COURTENAY TRACY OTTER HOUNDS. The pack was founded in 1887. Members came from miles around and coursed over an area covering Hampshire, Wiltshire, Dorset and parts of Somerset. Kennelled originally at Wilton, they moved to Netheravon in the early 1900s when Captain A.E. Hussey became Master of Hounds. They then returned to Wilton and eventually became a mink hound pack. The picture shows the huntsmen resplendent in their dark green coats, white breeches and peaked caps.

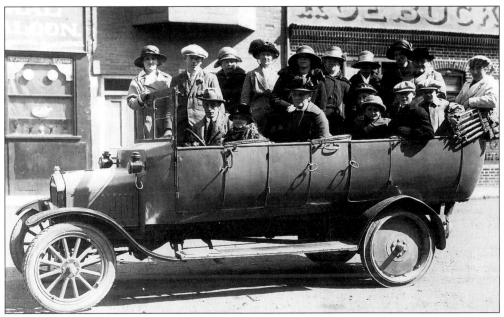

AN OUTING TO SALISBURY IN THE 1930s. Joseph Whitmarsh's charabanc is pictured here outside the Roe Buck Inn in the Canal. Notice the combination of soft tyres on the front and solid tyres and disc wheels at the back of this 20 hp Model T Ford. There are seventeen passengers packed into this tiny vehicle. Joseph Whitmarsh ran a garage in Netheravon which his son Arthur carried on until after the Second World War.

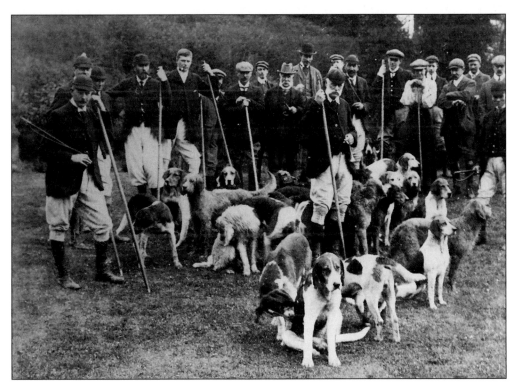

THE POST OFFICE AT FIGHELDEAN, 1907. The sub-postmaster at the time of this photograph was Enos Sheppard, who received letters each day through Salisbury at 6.05am and 1.55pm. These cottages in Mill Lane can still be seen on the opposite side of the road to Figheldean House. The post office was later moved to a cottage near the blacksmith's shop. Mrs Whatley was postmistress there during the 1920s and '30s.

UNDER THE SPREADING CHESTNUT TREE AT FIGHELDEAN. This is the very epitome of the scene in Longfellow's famous poem, but one of eleven claiming to be the original. Since the early nineteenth century the smithy was to be found here. At around the time of the First World War Burnard Sheppard worked here as a farrier, general blacksmith and carrier. Today it is an artist's gallery.

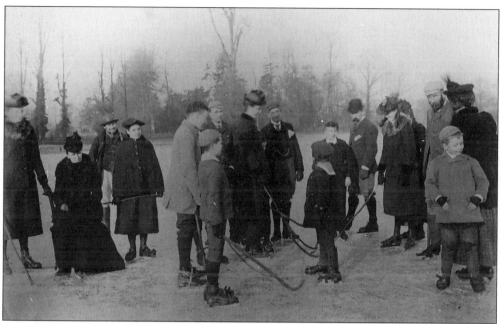

FUN ON THE ICE. Taken at Brigmerston, this unusual picture shows a family party enjoying a game of ice hockey on the frozen meadows. The girl depicted fourth from the left is Rachel Dorothy Shuttleworth Rendall of Brigmerston House. Many memorials of that family can be seen in Milston Church. The old lady sitting on the left does not appear to be entering into the spirit of the occasion!

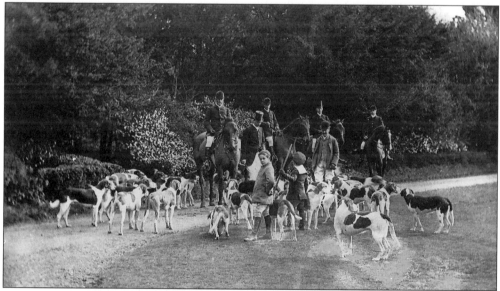

THE TEDWORTH HOUNDS AT BRIGMERSTON. The Hon. Percy Wyndham of Clouds House, East Knoyle, was for many years the Master. The picture was taken on the front lawn of Brigmerston House which is now converted into flats. A semi-circular path passed in front of the house built by Charles Rendall (a local landowner) in the mid-nineteenth century. Little Wood can be seen in the background. This photograph is undated but would appear to have been taken at around the time of the First World War.

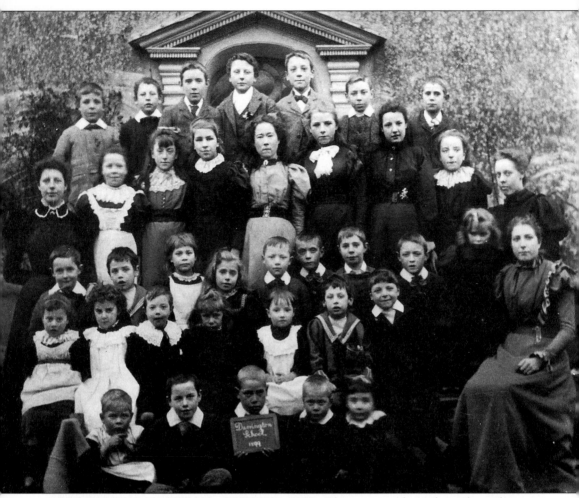

DURRINGTON NATIONAL SCHOOL, 1899. This group of pupils and teachers are assembled in front of Holmlea, a residence on the corner of Church Street and College Road. The teacher on the right is Miss Hamlyn, later to become Mrs Batchelor. Miss Toomer, who was a pupil teacher, is shown on the left. Her uncle was Gilbert Toomer, the owner of the house. The headmistress, Miss Katherine Adamson, is not present. Sam Toomer is the fourth pupil from the left in the back row. Laura Macklin is fourth from right in the row below. The school was built in 1850 by the Reverend Richard Webb. It is now the church hall.

Opposite: BULFORD ROAD, DURRINGTON, IN 1916. Behind the mounted soldiers stands The White Cottage, which can still be seen today although it is now tiled. The old cottages on the left have been demolished. The building at the far end of the road was Bartlett Ranger's drapery, and out of view to the right of the shop is Ambrose Ranger's farm, now a large residential area. The chapel on the right is now the Durrington Congregational Free Church.

THE STONEHENGE INN, DURRINGTON IN THE 1920s. The inn was originally built by William Toomer in the 1860s as the Crossroads Brewery. Because of its remoteness from the centre of the village however, local people referred to it as 'Toomer's Folly'. London coaches regularly stopped here for a change of horses on route to Devizes and Bath. During the Great War the inn was bought by Portsmouth Breweries as a brewery and distribution depot for other local pubs. The army camps were also supplied. The Australasian soldier has a black band around his arm and he carries a baton. Perhaps he was a military policeman?

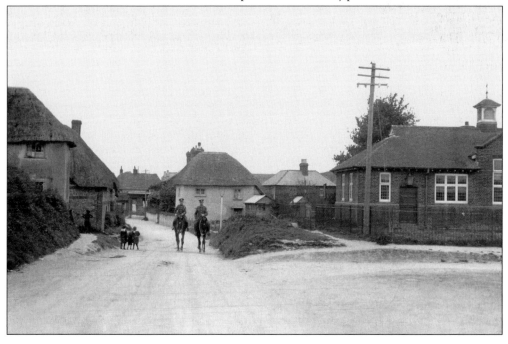

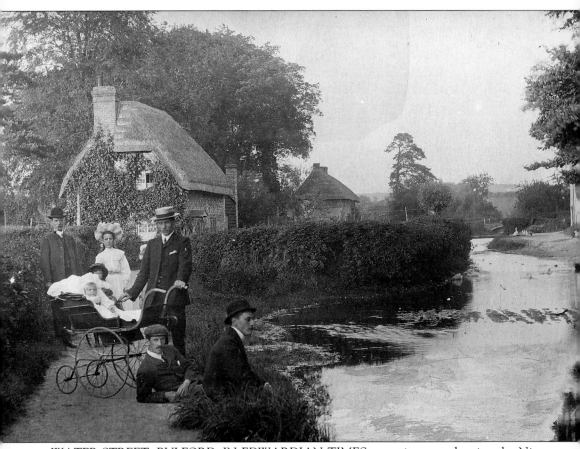

WATER STREET, BULFORD, IN EDWARDIAN TIMES, a rustic scene showing the Nine Mile River which runs into the Avon near here. The thatched cottage to the left is now known as Chimneys. The group of people are standing with a baby carriage known as a bassinet. During the 1960s a charity pram race, the 'Idiots' Race', was held each Boxing Day along this stretch of river. Even though it is next to the busy Bulford Road there remains an air of tranquillity about this spot

THE ROSE AND CROWN, BULFORD. The landlord, Alfred Leaker, is sitting beside his wife in the front row surrounded by members of his staff. The young man on the left appears to be proud of his belt which is covered with army badges. Mr Leaker was the landlord here from 1916 to the early 1920s when it was popularly known as 'the soldiers' pub'. The inn was also the local of Percy Toplis, 'the monocled mutineer' mentioned on page 97.

MANOR HOUSE, BULFORD, 1918. This imposing residence was built in the seventeenth century of stone and flint but has had many additions since. A group of wounded soldiers can be seen standing outside the main entrance. This picture postcard was sent by a patient to his sister in Middlesborough. He complains, 'It is nice food we are getting but not quite enough. We have not had our kit yet. I hope it won't be long as I won't be able to go out as my pants are splitting up the back.' The manor is reputed to be haunted by a house maid who was made pregnant and threw herself into the mill race from an upstairs window.

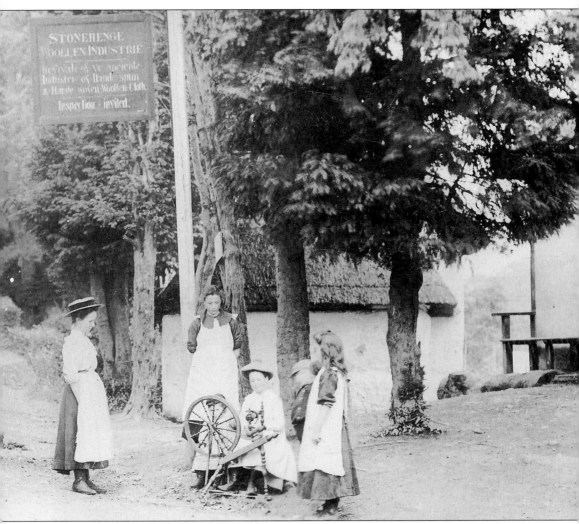

THE STONEHENGE WOOLLEN INDUSTRY AT LAKE, IN AROUND 1906. The following words can be seen on the sign: 'STONEHENGE WOOLLEN INDUSTRIE Revival of ye anciente industrie of hand spun and hand woven woollen cloth. Inspection invited.' At the end of the nineteenth century the Lovibond family of Lake House started this cottage industry for women. It harked back to the prosperity which the cloth trade had brought to the village in previous times. The workers produced a sort of 'rough tweed in pretty colours made on hand looms'. The small thatched workshop behind the trees has survived and is known today as Fir Tree Cottage. Fire has twice destroyed the neighbouring Diamond Cottages.

UPPER WOODFORD COTTAGE, 1910. This is the home of Harry Harding, a carpenter and wheelwright who inherited the cottage from his father Luke, also a carpenter. Harry is standing with his mother Annie Harding. The cottage is now known as The White Lynch. Out of view to the left lies a blacksmith's shop where Leonard Moody, the last village blacksmith, plied his trade for sixty years.

WOODFORD ELEMENTARY SCHOOL. Charlie May photographed this group of happy children in 1906 or 1907. The school was built in 1872 with a house attached. It provided education for 100 children, but when this picture was taken the average attendance was only 50. Mrs Emma Grasse was the school mistress. It is now the Woodford Church of England Primary School, the last left in the Woodford Valley.

THE BOURNE VALLEY BAND OF HOPE AT NETTON. The rally was held in a field behind the Wesleyan Chapel with which the Band of Hope was strongly associated. A banner with the words 'Union is Strength' can be seen in the background. Open air meetings such as this would not have impressed the landlord of the Crown Inn! The Temperance Movement, with which the Band of Hope was linked, continued its crusade against alcohol well into the twentieth century. Netton Chapel, school and inn are all now private dwellings.

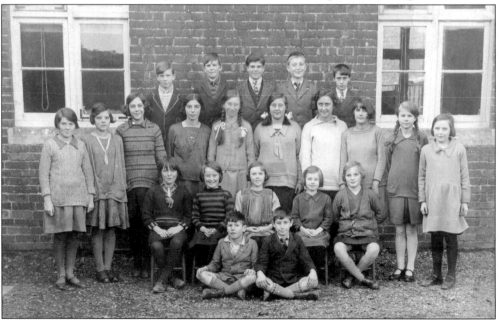

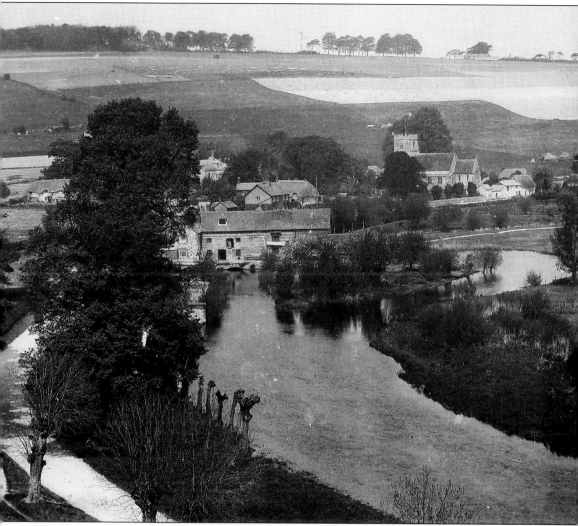

THE WOODFORD VALLEY BEFORE 1910. This tranquil view was taken from Lower Woodford, looking north along the River Avon. There is a ford along this stretch of water enabling horse-drawn wagons to cross. Middle Woodford Mill, owned by the Rasch family from Heale House, lies in the centre, with Middle Woodford Church in the distance. The meadows of Geoffrey Langdon's Salterton Farm can be seen to the right. They are no longer 'drowned' but are part of an Environmentally Sensitive Area (ESA).

Opposite: PUPILS OF NETTON SCHOOL, 1932. Joe Penny and Douglas Spencer sit with legs crossed in front of the group. Behind them in the second row are Lily Hazzard, May Low, Margery and Maud Grinter and Grace Hosier. There are ten girls in row three: Nellie May, Ruth Hosier, Olive Scarrott, Joyce Middlecott, Mary Palmer, Kathleen Thornton, Ruth Thornton, Joyce Dunford, Gladys Abbott and Irene Jenkins. Left to right in the back row are the Brinstone brothers, an unidentified boy, Dennis Green and Ken Thornton. Netton School closed after the Second World War.

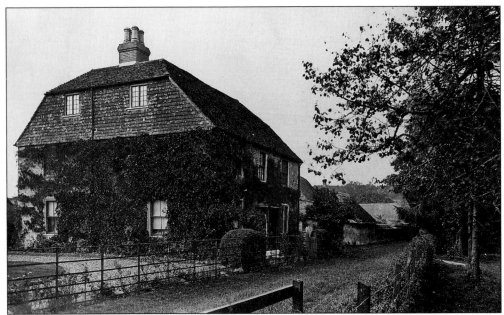

CHURCH FARM HOUSE, GREAT DURNFORD, IN AROUND 1906. Cecil and Reg Langdon farmed here at the time of this photograph. The farm was leased from the Tryon family at Great Durnford House. An old brewhouse and bakehouse, previously used for the village, still survive in the garden. It ceased to be a farmhouse between the wars and for the last twenty years has been the home of Dreda Lady Tryon.

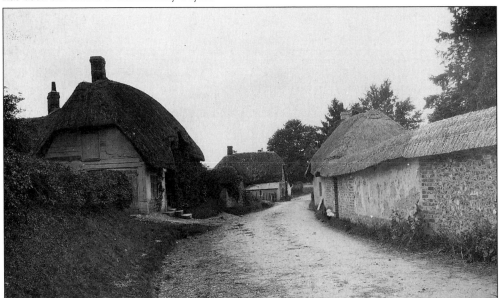

GREAT DURNFORD AT THE DAWN OF THE TWENTIETH CENTURY. The cottage on the left was for many years the village post office, Mrs Stokes being the last postmistress. A mounting block can still be seen outside. The thatched wall on the opposite side of the road has long been demolished. A sweet shop, dairy and piggery once stood in this area. The cottage in the centre, previously the home of Mr Goodrich, has also been demolished. Further round the bend lies the Black Horse Inn.

Six
Bourne Valley

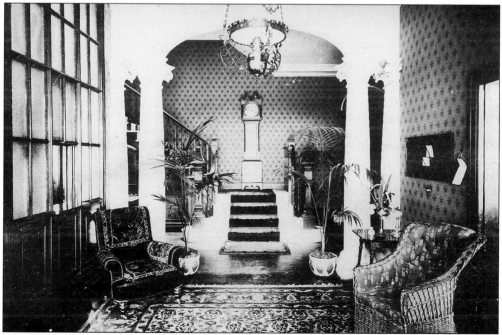

THE PRINCE OF WALES HOTEL, LUDGERSHALL, 1907. An air of Edwardian elegance is reflected in this view of the entrance hall. The hotel was much frequented by army officers and visitors from the nearby camps. Edward Pass was the manager at the time of this photograph.

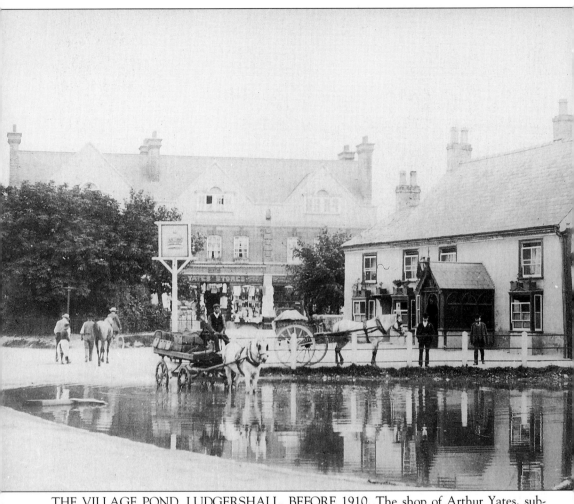

THE VILLAGE POND, LUDGERSHALL, BEFORE 1910. The shop of Arthur Yates, sub-postmaster and grocer, can be seen in the background, and on the right is The Crown Inn where Percy Judd Stockley was the licensee. The horse-drawn brewers dray has probably just made a delivery and the drayman is 'wetting his wheels'. Noisy carts and wagons were a source of irritation at the time. When dry, wooden spoked wheels were prone to squeak; soaking them in water caused the wood to expand and thus temporarily cured the squeak. The horse is also taking the opportunity to refresh itself.

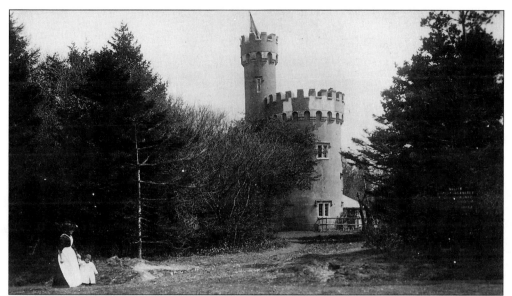

THE ROUND TOWER, TIDWORTH, BEFORE THE GREAT WAR. The tower, now demolished, was a landmark built so that the crippled daughter of Thomas Assheton Smith could watch the hunt. Assheton Smith was the Lord of the Manor and a celebrated Master of Hounds who founded the Tedworth Hunt. You may just be able to see a young girl standing at the base of the tower. A warning sign stands in front of the trees on the right. 'NOTICE. No persons except those on duty are permitted to enter this wood.'

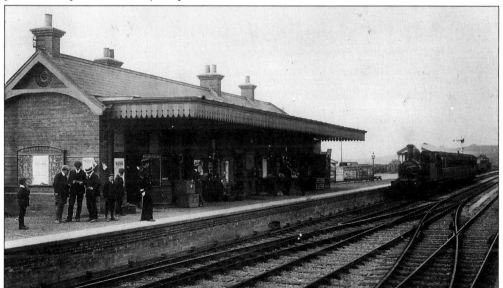

AN EARLY VIEW OF TIDWORTH RAILWAY STATION. Linked to the main line at Ludgershall, the line was opened on 1 July 1902. Being the first railway to be built on the Plain, it was constructed initially to assist the building of the camps and for the movement of troops. The line was owned by the government and leased to the Midland and South Western Railway Company. Until it closed in 1958, two locomotives known affectionately as 'Molly' and 'Betty' carried straw and feed for the army horses, coal and other provisions right into the Tidworth Barracks.

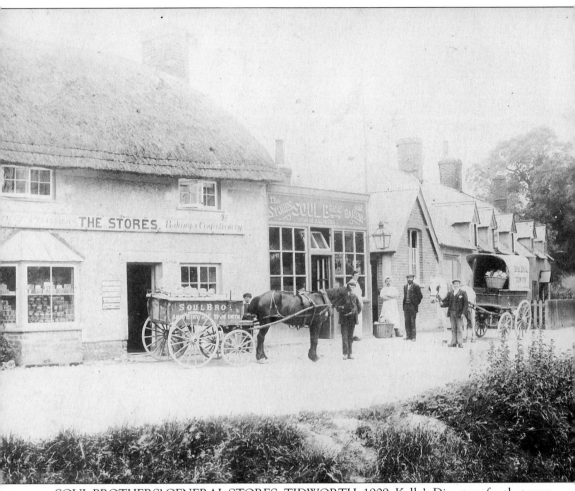

SOUL BROTHERS' GENERAL STORES, TIDWORTH, 1909. Kelly's Directory for that year emphasises how busy their lives were: 'bakers and confectioners, grocers and provision dealers. Families and officers' messes waited on daily.' Soul Brothers had another store at Amesbury. The open cart on the left is about to depart with a consignment of cottage loaves and the covered van would appear to be carrying an assortment of bread. Out of view to the right is the Ram Hotel which is still a busy hostelry for the troops. In September 1909 a young lady named Alice sent this picture postcard to Miss M. Coleman of The Moorlands, Devizes. These are her words: 'This is the style of the place in which I am. Do you notice the thatched roof? The houses are nearly all after that style. Nearby are the Salisbury Plain Barracks so soldiers are continually passing through the village on the march and we hear plenty of military bands and bugle calls.'

THE NEW BURIAL GROUND AT NORTH TIDWORTH. This picture records an historical moment. The Bishop of Salisbury, F.D. Ridgeway, enrobed in cope and mitre, is consecrating the new cemetery at North Tidworth Church in April 1917. He is accompanied by, among others, the rector, the Reverend F.R. Carr.

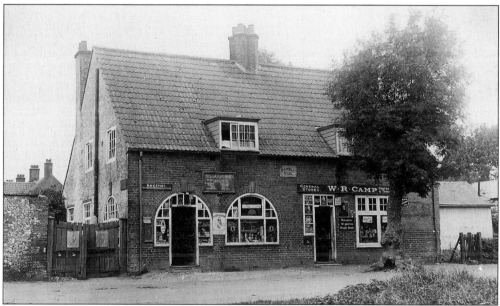

HAMBLE HOUSE, SHIPTON BELLINGER, IN THE 1920s. William Sturt, the Shipton draper and outfitter, has his shop on the left. He boasts a variety of goods including toys, cigarettes, tobacco, refreshments, cycles and accessories. William Reginald Camp's store on the right concentrated on confectionery and general provisions. There are a number of enamel signs fixed to the building, one or two of which would not seem too out of place today: 'Remember the good tea – Brooke Bonds' and 'Cherry Blossom Boot Polish'.

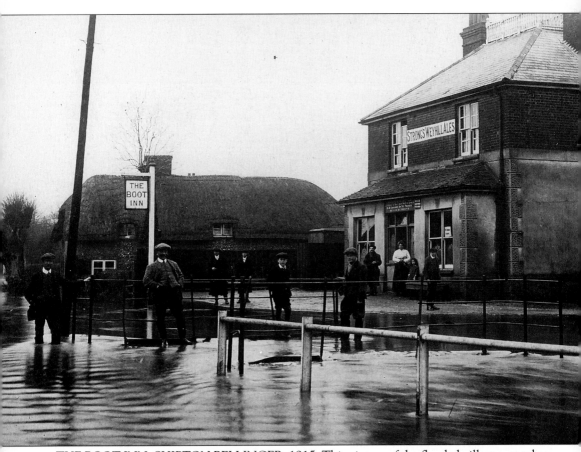

THE BOOT INN, SHIPTON BELLINGER, 1915. This picture of the flooded village was taken during January in the middle of the worst winter experienced on the Plain for many years. Andrew Noyce was the landlord of the pub at that time. The inhabitants look surprisingly unperturbed by their misfortune! The village takes its name from the Beringer family who held the manor in the thirteenth century; Shipton, literally 'sheep ton', reminds us of the area's original use.

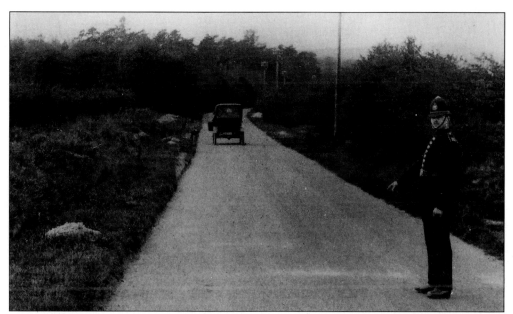

THE SCENE OF A SHOCKING MURDER, 25 APRIL 1920. Percy Toplis sprinkled chalk from a roadside heap onto the bloody smears left in the road by his victim, Salisbury taxi driver Sydney Spicer. The incident happened east of the junction of the A303 road with the Parkhouse turning to Tidworth. Toplis, known as 'the Monocled Mutineer', was an army deserter. He was killed in an ambush later that year. The police officer from Andover is pointing at the chalk marks for the benefit of the photographer.

TUPPNEY COTTAGE, CHOLDERTON. The picturesque cottage on the left was built in the late eighteenth or early nineteenth century but has experienced many changes since then. It has also had many owners. One of them was Henry Charles 'Inky' Stephens (1841-1918), whose father invented the famous writing fluid. Henry is buried at St Nicholas's Church, Cholderton.

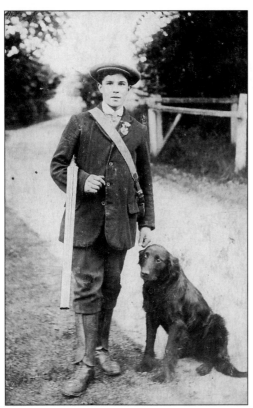

TOM WILLIAMS – A WILBURY HOUSE GAMEKEEPER. There were six children in the Williams family. This lad was one of them. Tom sent this photograph to his brother Charlie: 'To dearest Charlie with best wishes and good luck from your loving brother Tom.'

NEWTON TONY STATION, 1914. The Amesbury and Military Light Railway was opened in 1902 to provide a link between the main London and South Western Railway and the military camp at Bulford. Newton Tony was an intermediate station between Amesbury and the junction at Grateley. The station master, Joseph Norwood, can be seen beyond the lady with a pram.

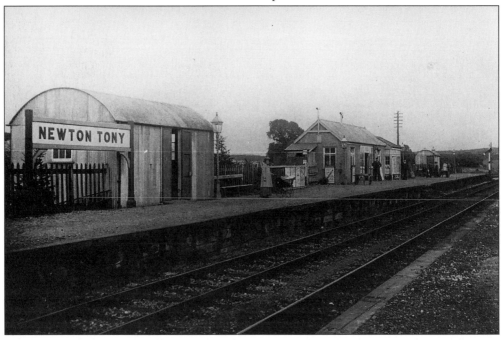

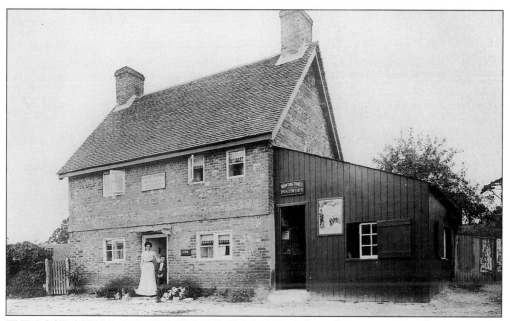

THE POST OFFICE AT NEWTON TONY IN 1907. A framed poster urging enlistment to the Royal Marines can be seen on the wooden lean-to. Above the door is a more permanent Post Office sign on which has been incorporated the alternative spelling of the name of this village, 'Newton Toney'. The sub-postmaster was George Brown, a butcher and licensed retailer of tea and tobacco. His daughter, Mrs Ferris, can be seen at the door of the house with her son Frank. This was a busy place with letters arriving from Salisbury seven days a week. Mail was sent out once only on Sundays but twice daily during the remainder of the week.

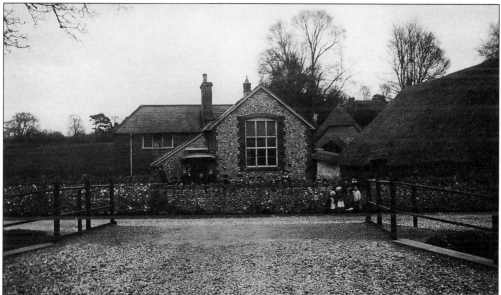

THE BRIDGE AND NEWTON TONY SCHOOL, AROUND 1914. The school was originally built in 1885, but was burnt down on Bonfire Night in 1952. (Many thought it was the bonfire planned for that occasion!) Pupils were then taught in the adjacent Memorial Hall until the new school was completed. The bridge was constructed in 1911.

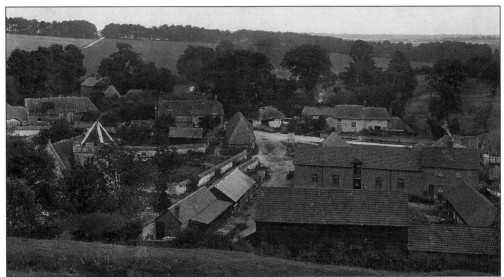

ALLINGTON DURING THE EARLY YEARS OF THE TWENTIETH CENTURY. We are looking towards Newton Tony with the line of trees across the centre marking the parish boundary. The pigsties of Wyndham Farm can be seen in the foreground, and in the centre of the picture stands Young's Stores and the Methodist chapel. The parish church of St John the Baptist lies in the left foreground, with Wyndham farmhouse beyond. Many of the remaining buildings have been demolished.

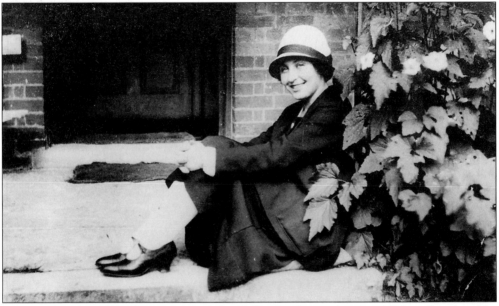

AN ENGLISH ROSE. This attractive lady, Nellie Steele, was born in 1907 at Grateley. She was the only daughter of a ganger working on the London and South Western Railway line from Waterloo to Salisbury. Her father died when she was only eleven months old and her mother, living on five shillings a week, found it difficult to keep her and her brothers Arthur and Ernie. She was taken into the Rectory at Allington by the vicar and later worked there as a maid. In 1933 she married Jim Allen, a heating engineer. During the Second World War she worked for Dr Curtis, a scientist at Porton. She is shown here outside the Allington Rectory.

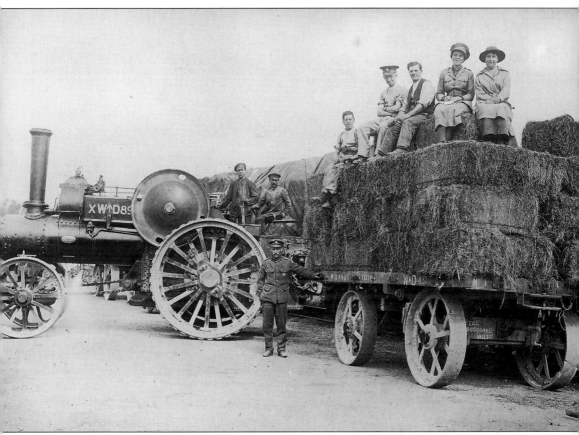

A MILITARY CONSIGNMENT AT BOSCOMBE. A joint civilian and military exercise would seem to be taking place here at the time of the First World War. A fleet of War Department traction engines and trailers are in the process of removing bales of hay from East and West Farms at Boscombe. The goods were probably being transported just a short distance by road from Robert Jackson Read's farms to the railway stations at Newton Tony or Porton, from where they would be forwarded to the horsed units on Salisbury Plain. One can just detect a railway line running alongside the wagon on the right of the picture and the wheels of a second road locomotive can be seen in the distance. These large metal monsters were type TE2 steam haulage engines manufactured by John Fowler and Company of Leeds. They were part of an order for 75 units (Nos 14908-14982) supplied to the government.

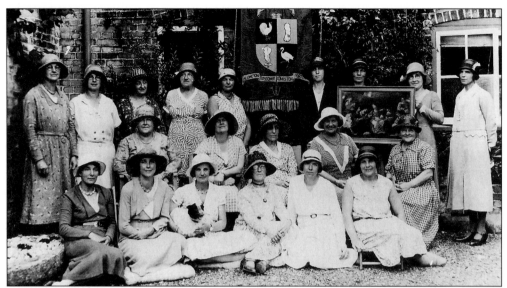

THE BOSCOMBE AND DISTRICT WOMEN'S INSTITUTE. The colourful banner, made by members and now preserved in the church, shows that this branch embraced the villages of Allington, Boscombe, Idmiston and Porton. Mrs Dorothy Macan, pictured beneath the banner, was president of the group during the 1930s. The branch declined and was brought to a close after the Second World War. The photograph, taken outside Queen Manor (Mrs Macan's home), also shows Mrs McCann and Mrs Elsie Miles holding a framed picture. In front of them with her hands clasped is Mrs Coleman. Mrs Laura Day can be seen at the left of the front row with her daughter Laura Robinson and Betty Wagg on her left.

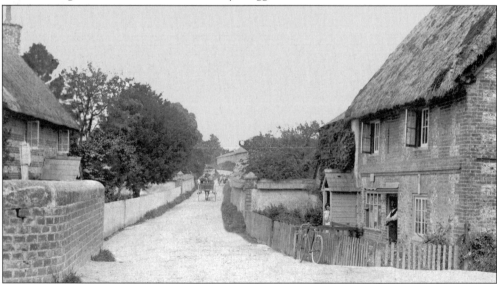

THE VILLAGE OF BOSCOMBE, BEFORE 1908. In the closing years of the nineteenth century the local sub-postmaster was William J. Sheppard, seen here in the doorway of the post office he ran for over twenty years on the right of the picture. This is now a private residence known as White Cottage. On the extreme left are some agricultural workers' cottages belonging to the Queen Manor estate. The original of this photograph has almost faded away but now looks quite fresh thanks to some skilful computer enhancement.

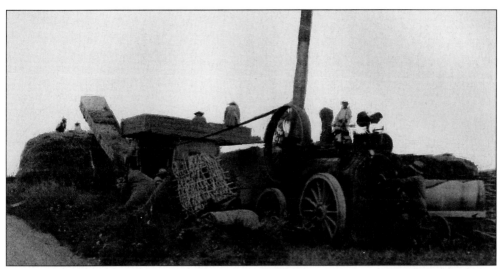

ACTIVITY AT HALE FARM, IDMISTON, IN THE 1920s. This farm, along with others, was owned by Eustace Bertram Maton of Coombe Farm, Enford. Charles Marsh was the farm bailiff around this time. His daughter was the church organist at Porton. Here we can see a threshing machine in operation. It was a filthy and noisy job. Having extracted the grain, the residue is transported to the loose haystack seen in the background. The agricultural steam engine was manufactured by Marshall of Gainsborough in around 1880. It is a portable horse-drawn engine designed in 1872. Known as the Improved Single Cylinder model, it could generate 10-12hp.

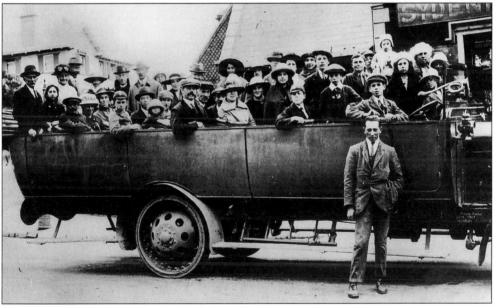

AN IDMISTON CHURCH OUTING IN 1921. A familiar scene to many day-trippers of the twenties and thirties, this is Pier Approach at Boscombe, Bournemouth. Sydenham's post office stands in the background. The Thornycroft charabanc was operated by Salisbury and District Motor Services (E. Coombes, proprietor) of Queen Street, Salisbury. Fred Tribble is the young lad pictured behind the wheel and Isabella Lawrence is under the letters S and Y of Sydenham's fascia sign. The man sitting over the rear wheel with his arm over the side is Albert Stone, the blacksmith, churchwarden and bell ringer.

'JACK' CALLAWAY AND HIS WIFE AGNES (NEE WILLIAMS). The couple lived at Porton and had seven lovely children. John (known as Jack), of Vine Cottage in the High Street, was a maker, capper and thatcher of cob walls. He was the last of the village drowners (men who cut out the channels that irrigated the water meadows). He also repaired the hatches by which the meadows were flooded.

AN AUSTIN DELIVERY VAN AT PORTON IN THE THIRTIES. E.W. Kail and Son were bakers and grocers. Anna Valley Motors of Salisbury supplied the firm with a pair of Austins in 1932, of which this is one. The driver is named Tom. Seventeen years later (1949) the van was sold to William Bradbury, then the licensee of the Porton Hotel (previously the Railway Hotel). Later on his daughter Pat and her husband Richard Eckersley learnt to drive in it. The van carries a Hampshire registration number (CG 2907).

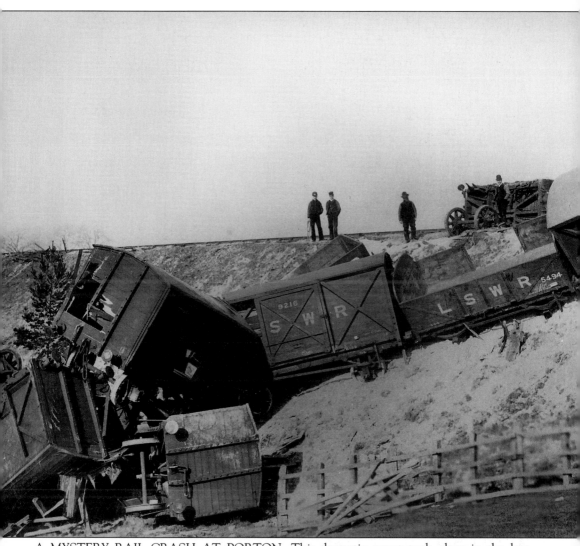

A MYSTERY RAIL CRASH AT PORTON. This dramatic event took place in the late nineteenth century. The carriages have become derailed and have fallen down the steep embankment of the London and South Western Railway line. Despite having made many enquiries, I have no further facts about this unfortunate accident. Can any readers help?

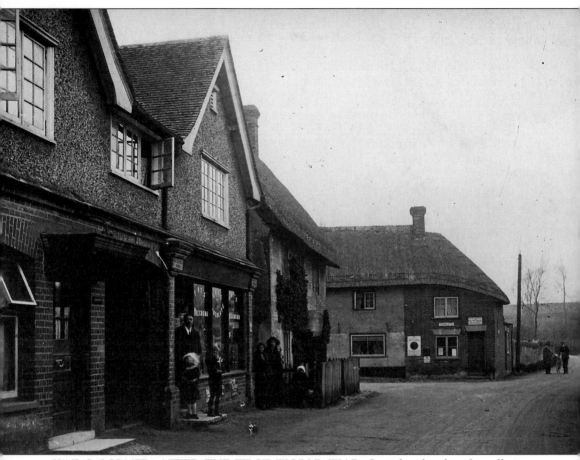

KAIL'S CORNER, AFTER THE FIRST WORLD WAR. Straight ahead is the village post office, where Eveline Kail was the sub-postmistress. There have been five or six different locations for post offices in Porton during the twentieth century. Kail's bakery and grocery store can be seen to the left. The firm were there in 1911 and remained in business until the 1960s. The shop remains but has been extended onto the site of the old Bell Cottage beyond.

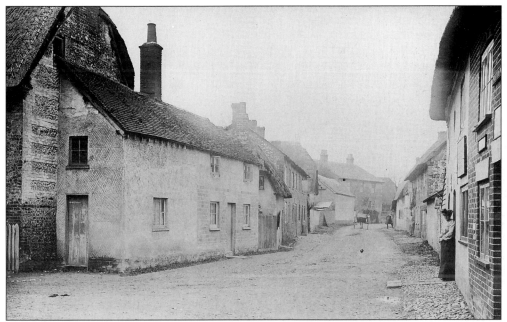

PORTON HIGH STREET, EARLY IN THE TWENTIETH CENTURY. We are looking towards Gomeldon. The post office is shown on the right and Bell Cottage is on the immediate left. The house with the steep thatch further down on the left is reputed to be the oldest in the village. In the far distance can be seen the old rectory. Many of these properties have now been demolished.

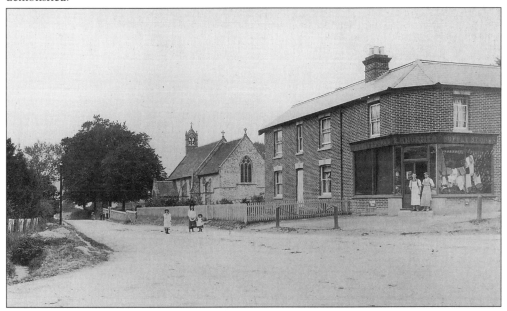

CHAPMAN'S CORNER, PORTON, BEFORE 1910. Horner's supply stores can be seen on the right with the parish church of St Nicholas (re-built and re-consecrated in 1877) coming into view beyond. It was a chapel-of-ease until joined with All Saints' Church at Idmiston in 1978. The road to the Winterbournes lies to the left of the picture whilst that to Idmiston runs to the right past Horner's shop.

SILVER STAR REMEMBERED, JUNE 1988. Enthusiasts are pictured here with two Leyland Tiger Cub coaches of 1955 vintage in front of the Guildhall at Salisbury. Standing to the left with MMR 553 is Gordon White (a director of Silver Star when the firm closed in 1963) and David Dawes of Dewsbury who had preserved the coach. With MMR 552 are Michael Shergold (also a director when the firm closed) and the coach restorer Jack Parsons of Eastleigh. Six former employees were among the group who turned out to see the coaches travel their old route through the Winterbournes to Porton. This was to celebrate the 25th anniversary of the firm's acquisition by the Wilts and Dorset Motor Company Limited. The service was started by Ben White and Eddie Shergold in 1923.

Opposite: WATERSIDE, WINTERBOURNE GUNNER, 1909. This mansion stands side-on to the A338 at Mill Corner, bordering the parishes of Gomeldon and Winterbourne Gunner. The small walnut tree in the centre remains as a beautiful mature example today. Behind can be seen an outhouse and the corner of the coach house which still retains its stalls for the horses. The message on the back of this picture postcard was written by a girl named Carlotta. 'I called [at the house] with Millie last friday and their eldest girl is to be married on Wednesday so we are hoping to go to their wedding.' Unfortunately, we are not told who the occupants were at that time.

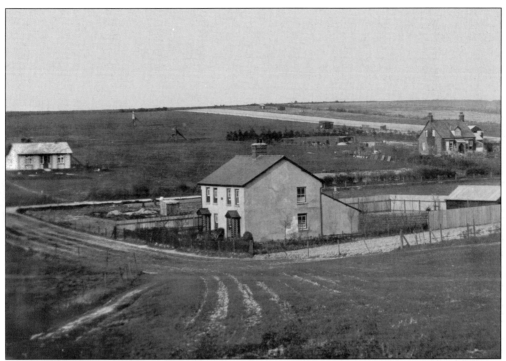

LADYSMITH, EAST GOMELDON, 1915, a very rural view of the land sold by William Carter in 1901. We are looking at a pair of dwellings called Athill Cottages which still remain. The little Asbestos-type bungalow on the extreme left was rented by a family named Hooper. It was burnt down in the early 1940s. Throughout the twentieth century the area has developed into the spacious village we see today.

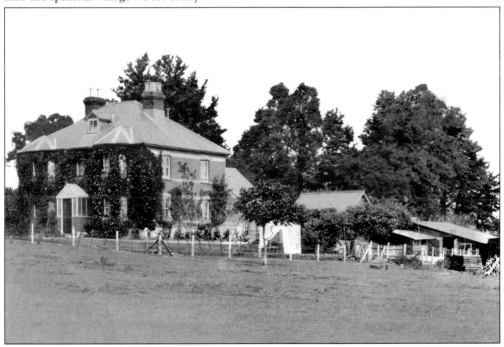

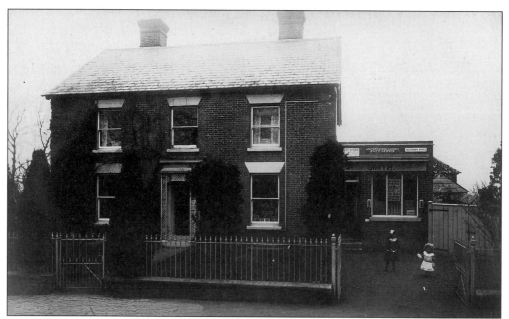

WINTERBOURNE GUNNER POST AND TELEGRAPH OFFICE IN AROUND 1907. The sub-postmistress at the time was Mrs Emma Smith, who was also the grocer. The business ceased trading in the 1960s and at the time of writing Marsh Motors (second hand car dealers) operates on the site.

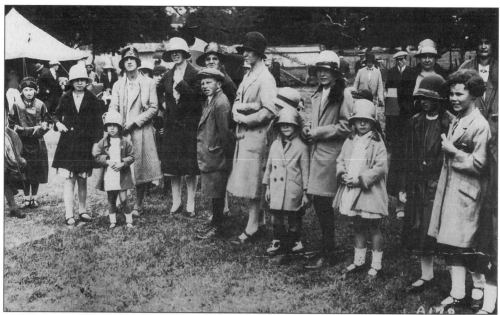

A FETE AT WINTERBOURNE EARLS IN THE INTER-WAR YEARS. Joyce Kelly is pictured to the right wearing a white coat. Sam Staples has a flat cap and he occupies a position in the middle of the group. Elsie Daybourne (née Staples) is standing behind the little girl on the left, her daughter Barbara. This event took place at Harvey's Field, which is opposite the church.

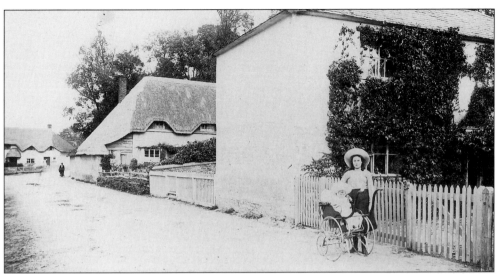

WINTERBOURNE DAUNTSEY AT THE DAWN OF THE TWENTIETH CENTURY.
Gladys Pocock is shown with her baby brother Edwin who was always known as Pat because he
was born on St Patrick's Day. In the years between the wars he was to keep the village post
office with his mother Frances. The children are standing opposite the New Inn (now called the
Tything Man) which is out of view to the left of the picture. The house behind them was
demolished a few years ago to make room for the new Methodist church. The next house down
is Middle Cottage, and in the distance on the corner of Gater's Lane stands Peacock Cottage.

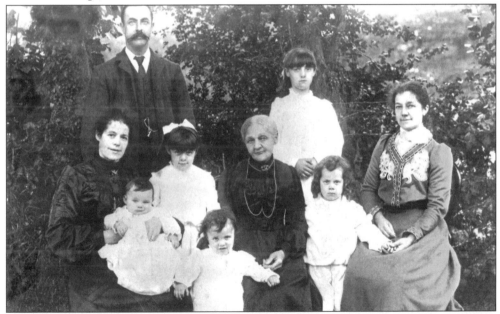

THE ROWDEN FAMILY OF WINTERBOURNE EARLS, 1902. Standing at the back is
Joseph Kinsmen Rowden, a partner in the building firm of Smith and Rowden of Winterbourne
Dauntsey. Next to him is his daughter Annie (later Mrs Bedford). Sitting on the left with infant
Joseph on her lap is Joseph's wife Eliza Emma. Next sits their daughter Gertrude (later Mrs
Eckersley), then Joseph's mother Jane, his son George and his sister Annie who kept the
Bulford Village post office. Standing in front is his daughter Norah (later Mrs Bridge).

MILITARY MANOEUVRING IN GATER'S LANE IN THE MID-1930s. In earlier times the road was known as Kelly's Lane after the family who kept the village store on the corner of the High Street. The tracked vehicles seen here crossing the ford are officially designated as Morris Martel two-man tankettes although the leading machine on this occasion appears to be carrying three occupants. There were numerous mechanised warfare exercises held on Salisbury Plain throughout the 1920s and 1930s, several of which are featured in the first volume of Salisbury Plain in The *Archive photographs* series.

HURDCOTT FARM EARLY IN THE TWENTIETH CENTURY. The large brick and flint house in the centre is Three Poplars. There was a mill close by in earlier times. The mill race passed beneath the arches of the low bridge as it made its way to the River Bourne. Hurdcott Farm was owned by the Bright family from 1916 to 1980.

Seven

Aviation

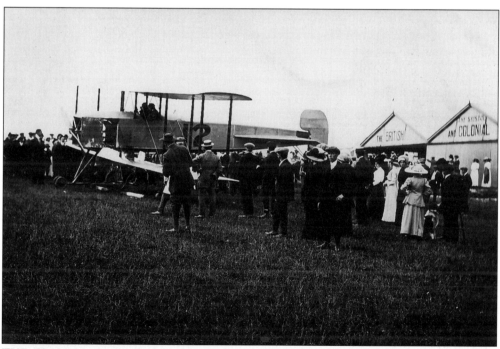

THE BRISTOL AND COLONIAL FLYING SCHOOL AT LARKHILL, 1912. Gordon England flew this Bristol Gordon biplane during the military trials that took place here from 1-25 August. He died on 5 March 1913 when his Bristol Coanda aeroplane crashed on landing. The coffin containing his body was carried to Woking crematorium on the back of an open motor car.

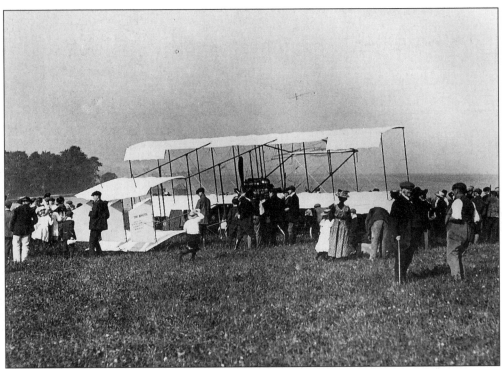

A BRISTOL AEROPLANE AT SHREWTON, 1910. In that year the Bristol and Colonial Aeroplane Company loaned the army a Boxkite and pilot for each of the sides ('Red' and 'Blue') that were taking part in a military exercise. One of the machines was piloted by Captain Robert Loraine, the actor, and the other by Captain Bertram Dickson. The aircraft shown here had probably run out of fuel and the pilot was forced to make an unsheduled landing in a field on the outskirts of Shrewton. It certainly attracted a great deal of attention.

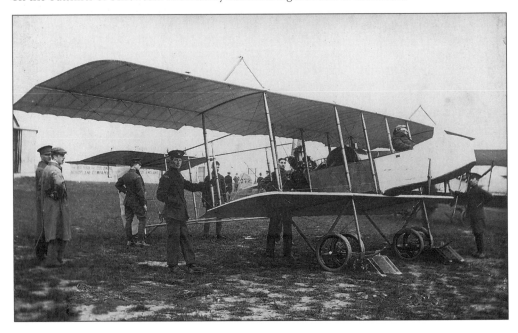

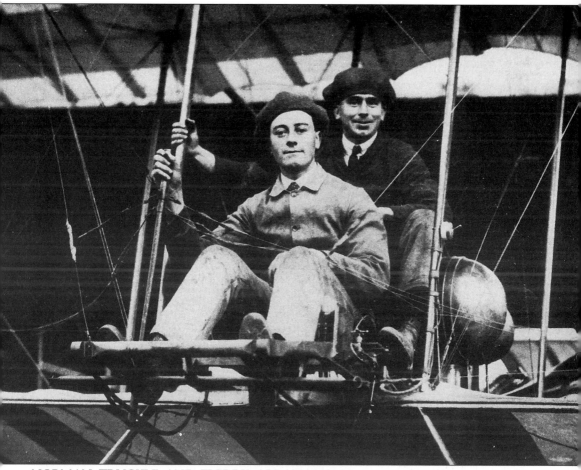

NORMAN TRUCKLE AND FREDDY ABRAHAMS. Norman is the young man at the controls of this Bristol biplane in 1912. Born at Amesbury, he started his career as a motor mechanic at Tom Collins' Garage. Soon he was maintaining engines at the Bristol Flying School where he was taught flying by Jullerot, the chief schooling pilot. In 1914 he qualified as a Royal Flying Corps fitter. He gained the RAF Meritorious Medal in the King's Birthday Honours List of 1919. In this picture he is seen characteristically wearing his hat back to front to face a strong head wind. Seated behind is his chum Freddy Abrahams, another lad from Amesbury who become an aeroplane mechanic.

Opposite: A HENRI FARMAN F20 BIPLANE OF THE ROYAL FLYING CORPS, 1912. This aircraft with an 80 hp Gnome engine was photographed near the 'Sun Gap' at Larkhill during the military trials. The Sun Gap was an area between the Bristol and Colonial Aeroplane Company hangars and the military hangars. It was a point where the sun rose during the summer solstice and was a convenient short cut to the aerodrome on approach.

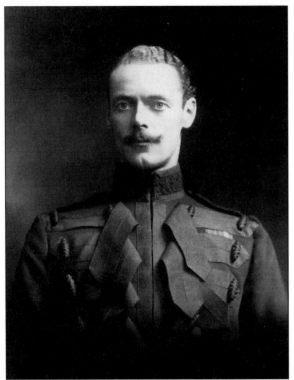

CAPTAIN EUSTACE BROKE LORAINE IN 1911 OR 1912. Captain Loraine was born in London on 13 September 1879, the eldest son of Rear Admiral Sir Lambton Loraine. A Grenadier Guardsman, he had served with valour in South Africa. In 1908, on promotion to captain, he was seconded to the West Africa Frontier Force where his Commanding Officer was Brevet Lt Colonel Hugh Trenchard. It was Loraine's courage and enthusiasm for flying which inspired Trenchard to turn in that direction also and later to play such an important role in the development of the RAF. Loraine and his mechanic Wilson (pictured right) were the first two aviators to be killed whilst on duty.

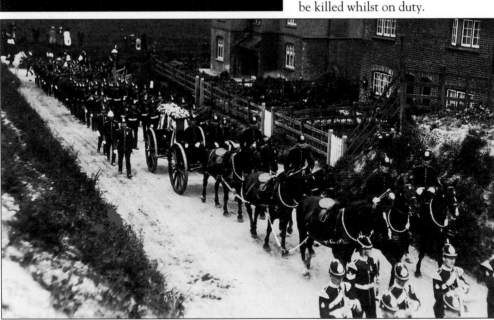

THE FUNERAL OF CAPTAIN LORAINE. Captain Loraine and Staff Sergeant Wilson died in the first fatal air crash on Salisbury Plain on 5 July 1912. Loraine was buried on 10 July at one of the largest military funerals ever seen in East Anglia. Here we see the gun carriage conveying his coffin through Bulford. More than 120 officers, non-commissioned officers, and men of the Grenadier Guards, together with detachments from the Royal Flying Corps, followed his coffin to the church at Bramford near Ipswich.

STAFF SERGEANT RICHARD HUBERT
VICTOR WILSON. Staff Sergeant Wilson
joined the Royal Engineers following his
apprenticeship at Tasker and Sons Limited
at Waterloo Iron Works, Anna Valley, near
Andover. He became a mechanic at the
Army Balloon Factory, Farnborough before
developing his expertise with aero-engines.
In 1912 he was one of the first to transfer to
the newly-formed Royal Flying Corps where
he was rapidly promoted to Staff Sergeant.
On 18 June 1912, having been taught by
Captain Loraine, he passed the tests for his
Royal Aero Club Certificate on a Bristol
biplane at Larkhill.

THE FUNERAL OF STAFF SERGEANT
WILSON, 1912. This photograph, taken in
Andover High Street, shows the band of the
Durham County Light Infantry leading the
procession. Following closely behind is a
gun carriage bearing the coffin. Mourners'
carriages and officers carrying floral tributes
can be seen in the distance.

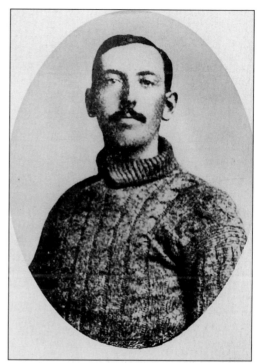

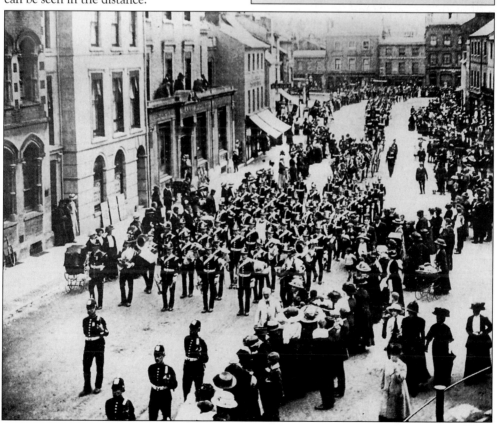

MEMORIAL TO MAJOR ALEXANDER WILLIAM HEWETSON. This monument is situated to the west of Stonehenge at the edge of Fargo Plantation on the A344. It commemorates the crash on 17 July 1913 in which Major Hewetson lost his life. The stone was carved by Jack Green of the Tisbury Stone Quarries (photograph inset below). Each year Dr Kennedy of Tisbury would take Green on an outing to see the memorial of which he was so very proud.

THE WRECKAGE OF A BRISTOL PRIER MONOPLANE AT LARKHILL. Major Alexander William Hewetson of the 66th Battery Royal Field Artillery was killed in this crash which occurred on 17 July 1913. He was a member of the Indian Army and came to Britain for flight training. While he was attempting figure-of-eight turns that would qualify him as a pilot, he lost control of his aeroplane and it crashed on the flying school field. Although aged only 45, he was considerably older than most pilots.

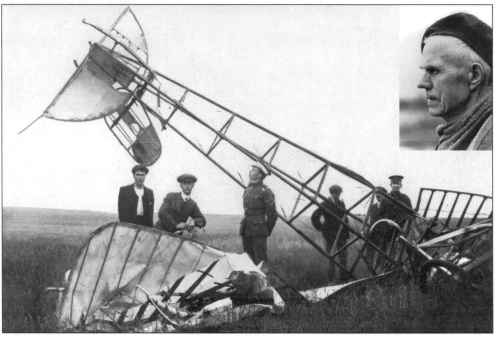

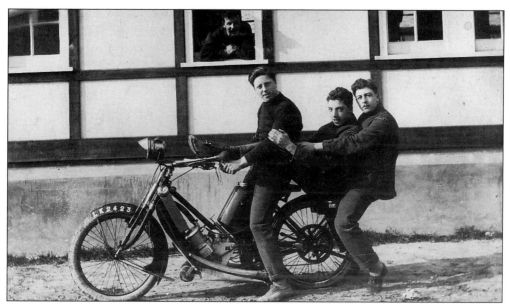

RIDERS FROM THE ROYAL FLYING CORPS. These three characters are sitting on a Scott motor cycle at Choulston Barracks, Netheravon. Before 1918 RFC personnel had flashes on their uniforms. The motor cycle was a sturdy two-cylinder two-stroke machine believed to be ahead of its time. LK 2423 is a London registration number issued in 1913. The black and white timber huts behind can still be seen today.

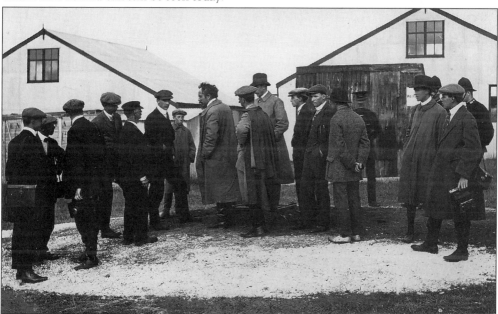

SAMUEL FRANKLIN CODY AT LARKHILL, 1912. 'Colonel' Cody had built and tested an aeroplane at Farnborough which, on 16 October 1908, made the first recorded power-driven flight in Britain. He is the hatless figure in the centre of a group of individuals assembled for the military aeroplane trials at Larkhill. An American by birth, he became a British subject in 1909 but was killed in August 1913 when travelling in one of his own aircraft. In the background can be seen the military hangars situated in Tombs Road.

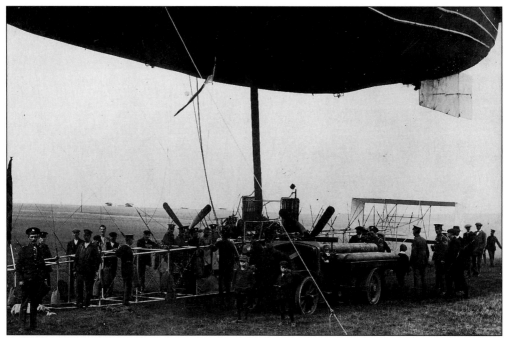

THE GAMMA ARMY AIRSHIP 1. Tom Fuller of Amesbury took this picture of an event which was obviously causing much interest. The Beta and Gamma class airships were occasional visitors to the Plain. This one had arrived on 22 September 1912 carrying six passengers from its base at Farnborough. The airship's hydrogen gas supply is being replenished from cylinders carried on the back of what appears to be a Canadian Kelly Springfield truck.

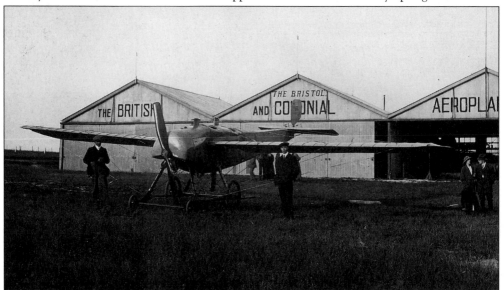

A BRISTOL COANDA MONOPLANE AT LARKHILL IN 1914. The Bristol and Colonial hangars can be seen in the background. A message on the back of this picture postcard, sent from Salisbury on 24 April, is as follows: 'We were nearly as close to the aeroplane as these people are and saw several of them start and come down after they had flown all round. Two aeroplanes came over here yesterday and flew round the spire of the Cathedral.'

Eight

The Photographs of Austin Underwood

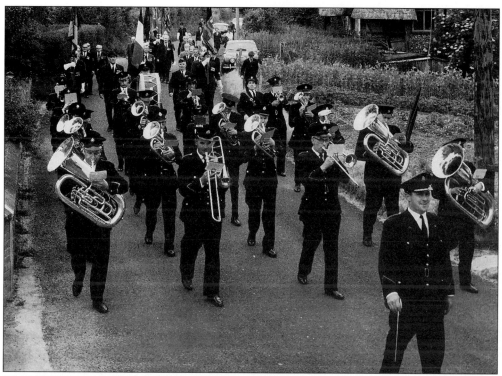

IN THE WOODFORD VALLEY, 1968. The Amesbury Town Band is leading members of the Dunkirk Veterans Association through Middle Woodford in the Avon Valley. The bandsman on the left in the front line is Dennis Burgess. The Old Workshop is shown in the top right hand corner. Austin Underwood's familiar Morris Traveller car can also be seen in the distance.

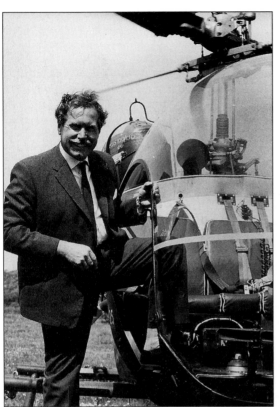

A LOCAL CELEBRITY AT NETHERAVON. Olly Kite was a river keeper and fisherman along the Avon who achieved national fame as a television personality. He is shown here arriving from Upavon in a Bell Helicopter to open the annual Car Rally at Netheravon.

LOCAL LAD WINS PLOUGHING MATCH, 1957. Fifteen-year-old Roger Moore is shown here on a Fordson tractor finishing his plot in the annual Salisbury and District Ploughing Match. The tractor has weights on its wheels to give it more traction. Roger won first place in the under-21 class for mounted ploughs. For many years now he has tended his own farm at Stapleford.

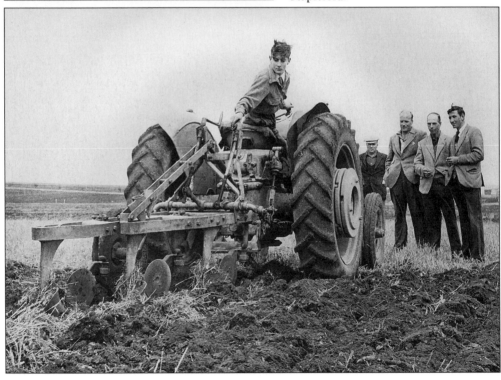

SCARECROWS AT CHITTERNE, 1964. This merry trio was photographed in an allotment on a bend in the road from Chitterne to Warminster. They were the creation of Donald Poolman who worked at Stratton Farm and made many of them over the years. The spot became known as 'Scarecrows Corner' after local huntsmen were looking for a convenient place to meet.

POTATO PICKING AT REDHILL FARM, AMESBURY IN THE EARLY 1950s. The farm, situated in Dog Kennel Road, belonged to Wort and Way. Boscombe Down married quarters can be seen on the horizon. 'Spud-picking' was always a back-breaking job which usually took place in October. Farmers had to grow a certain acreage of potatoes according to government regulations because of the post-war food shortage.

THE CONSTRUCTION OF A NEW PEDESTRIAN BRIDGE IN AMESBURY, 1957. In May a single-span 100 ft steel bridge with a six foot wide footpath was erected across the River Avon. It was placed alongside the Queensberry Bridge which at that time formed part of the main road carrying traffic from London to the West of England. The metal footbridge was mounted on rollers and winched across the river by a steam traction engine provided by James and Crockerell (builders and Government contractors) of Durrington. A second steam engine was secured to the opposite end of the bridge to act as a counterbalance. The road roller in the foreground (SMY 146) was also from the James and Crockerell fleet. It is powered by a diesel engine. Driving across the stone bridge in his 1946 Ford Prefect is Mr F.H. Caines of Maundrel Hall, Fisherton Street, Salisbury. The car was supplied to him by Pitts of Amesbury.

Opposite: SOUTH EAST WILTSHIRE'S CUBS AND SCOUTS SPORTS DAY, 1957. Urged on by their supporters, competitors in the under-13 obstacle race emerge neck and neck from a flattened tent obstacle. This annual event took place at Tidworth Oval Sports Ground. The pipe smoking scoutmaster is Frank Piesing, usually known as 'Skip'. He ran the Amesbury pack.

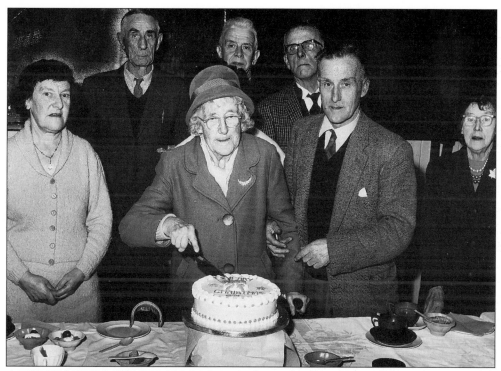

A DURRINGTON CHRISTMAS PARTY. Eighty-eight-year-old Mrs Annie Mills, the oldest member of Durrington's Disabled Club, cuts the cake at this Christmas Party. The event had been arranged by the club's committee for the local blind and disabled. Starting in Durrington in the mid-1960s, the club met in the village hall. When this was re-built, meetings were held at the Methodist Hall, Amesbury, where most of the members came from, and it never returned.

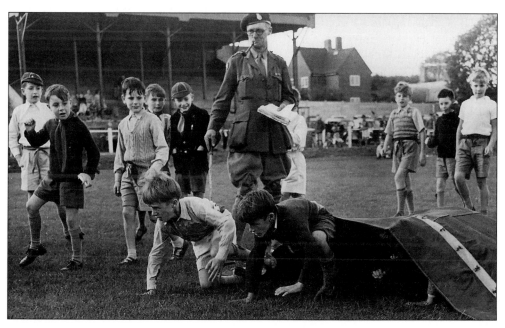

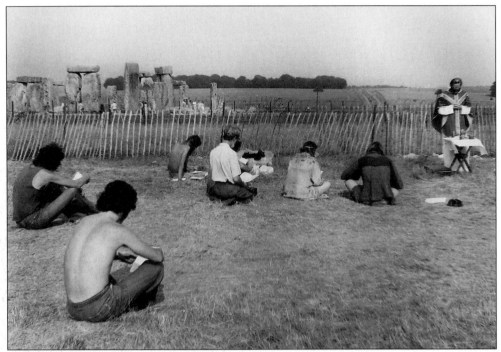

A HIPPY SERVICE AT STONEHENGE IN JUNE 1974. This religious event would have taken place at the time of the summer solstice. A more pagan ceremony for nudists seems to be taking place within the fenced area! Nude bathing also took place in the river below Queensberry Bridge.

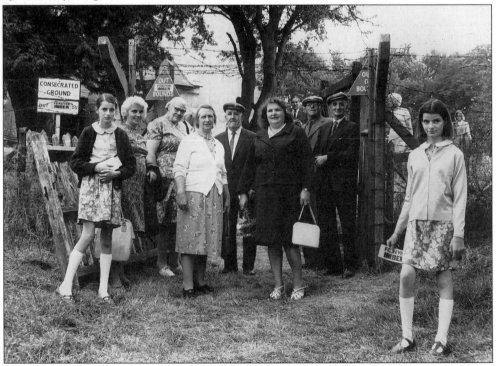

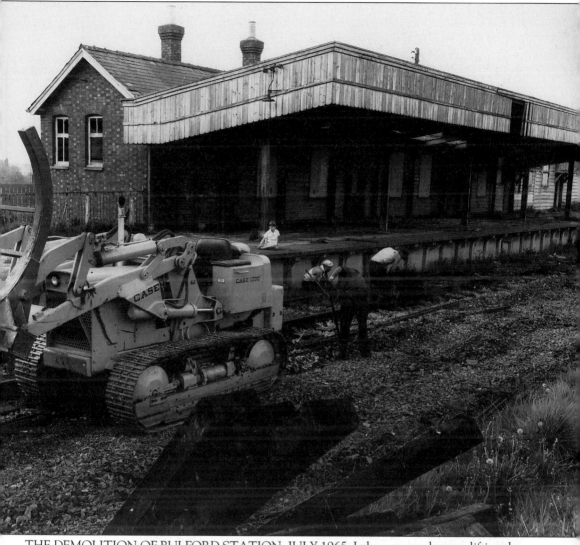

THE DEMOLITION OF BULFORD STATION, JULY 1965. Labourers can be seen lifting the track with the aid of a Series 1000 Case tractor to which is attached a special hydraulic device. It would appear that the machine could literally scoop up the heavy wooden sleepers. Having played such an important role in servicing the Bulford camps during two world wars, the line was beginning to decline from the late 1940s as road transport developed. The last passenger train left Bulford on Saturday 28 June 1952 with very little ceremony. Goods traffic continued until 4 March 1963 when the line was finally closed.

Opposite: THE ANNUAL REUNION AT IMBER, 8 SEPTEMBER 1969. Old residents of the deserted village can be seen here outside the fenced off area of St Giles' Church. Ruth and Judith Underwood, Austin's children, are standing on the left and right of the picture. You may also just be able to see that the official 'Out Of Bounds' signs have been partly obliterated by 'Forever Imber' stickers. This was the slogan of the Association for the Restoration of Imber, a campaign which Austin Underwood spearheaded in the early 1960s.

Acknowledgements

When we were compiling the first volume of Salisbury Plain in The *Archive Photographs* series, Rex and I were not sure how well the book would be received. Because of the nature of the area, and the hundredth anniversary of a permanent military presence on the Plain, we thought it appropriate that a large proportion of the pictures should feature soldiers, their camps and equipment. Thankfully the book is proving to be very popular and it was felt that a second album should be produced in which the pictures would predominantly illustrate the civilian side of life in the villages and towns of Salisbury Plain. In this Second Selection we have reproduced around 150 photographs of communities that are to found around five river valleys. We have also taken another look at the town of Amesbury, and with the apparent interest now being shown in the early days of flying we have included a group of pictures that feature the area's first aviators and aeroplanes. The closing section is once again dedicated to the work of Austin Underwood. Much of the territory and subject matter we have covered this time is new to us both and Rex and I have had more than ever to rely on the kindness and willingness of the people of Wiltshire to assist with our enquiries.

We are especially indebted to Mrs Mary Underwood for permitting us to reproduce another selection of photographs taken by her late husband Austin. The quality and content of his work can now be appreciated and enjoyed by us all.

The following individuals and organisations deserve our gratitude for providing specialist knowledge: Maureen Atkinson (Bourne Valley), Gwen Coles (Shrewton), Peter Goodhugh (Amesbury), Peter Goulding (railways), Peggy and Tom Gye (Market Lavington), Betty Hooper (West Lavington), Nancy and Tim Morland (Wilton), Norman Parker (aviation), Peter Parrish (steam engines). Also Dinton WI, Judith Giles and Bruce Purvis (librarians, Salisbury Local Studies Library), David Fletcher (librarian, The Tank Museum, Bovington), and the archivists and staff at the Wiltshire Record Office, Trowbridge.

We would also wish to thank the following people who have lent photographs or helped in some other way: Kenneth J. Alford, Jim Allen, Charlie Andrews, Ms D.B. Battye, Julian Beacham, Audrey Beeson, Frank Blewett, Peter Brooks, Jim Chick, Steve Chislett, Sylvia Chisman, Dr Dorothy Clark, Anthony Claydon, Lord de Saumarez, Kathleen Dent, Pat and Richard Eckersley, Ray Feltham, William Foyle, Sue Francis, T.L. Fuller & Sons, Betsy and Ted Green, Joyce Kelly, Terry Heffernan, Mrs K.M. Kent, Marian and David Kyte, Joan and Geoffrey Langdon, Frank Lee, John Lovelock, Tony Lyons, Catherine MacLennan, David Marett, Kathleen Mould, Air Vice Marshall B.H. Newton (retired), Lyn and David Perkins of Kallans Photography, Phyllis Patrick, John Pothecary, Michael Ranger, Rex Reynolds, Edna Richardson, David Ride, Joan and John Sawyer, Olive Scarrot, Keith Shaw, Roy Simper, Joyce Smith, Sue Teale, Ken Thornton, Elsie Tillyer, Mary and John Tole, Dreda Lady Tryon, Angela Turnbull (of the *Salisbury Journal*), Peggy and Jim Van Hagen, Mrs Van Der Kiste, John Vining of Farmer Giles Farmstead, Mrs A. Whittall, Mrs V. Williams, Harry Withers and Ivor Whitlock.

Peter R. Daniels
Netherhampton
September 1997